VICTORIA AND ALBERT MUSEUM . *Dept of Prints and Drawings.*

Old and Modern Masters of Photography

Selected and introduced by
Mark Haworth-Booth
Foreword by Dr Roy Strong

LONDON : HER MAJESTY'S STATIONERY OFFICE

© Crown copyright 1981

First published 1981

ISBN 0 11 290361 4 (limp cover)

ISBN 0 11 290362 2 (cased)

Printed in England for Her Majesty's Stationery Office by
W. S. Cowell Ltd, Ipswich

Dd699039 C70

Design by HMSO Graphic Design/Dennis Greeno

Acknowledgement

The introductory essay by Mark Haworth-Booth is based on a
BBC Radio 3 talk, produced by Louise Purslow, which was first
broadcast on Christmas Day 1979.

Note

A fuller commentary on the plates in this book is contained in the
exhibition catalogue *Old and Modern Masters of Photography* (Arts
Council of Great Britain, 1980). A colour microfilm of 10,000
photographs from the Victoria and Albert Museum collection
c 1840–1914 is available from World Microfilms Ltd, 62 Queen's
Grove, London NW8 6ER.

Cover

Isambard Kingdom Brunel and launching chains of The Great Eastern
1857
Robert Howlett British, died 1858
Albumen 28.6 × 23.2 246–1979
Purchase

FOREWORD

THE NATIONAL collection of photographs as art is housed as one of the manifold museums within a museum that make up the Victoria and Albert Museum. Its holdings, which originated with the founding of the Museum in the 1850s, are amongst the finest in the world. The Victorian ones alone include outstanding photographs by Fenton, Hill and Adamson, Julia Margaret Cameron, Le Gray, Camille Silvy and Lady Hawarden. These began their existence as part of the National Art Library and remain intact to this day. In 1977 the Museum's collection was transferred to the Department of Prints and Drawings but with the clear intent that it was a separate entity of rapidly growing significance. This will be reflected when that Department shortly moves to the Henry Cole Building when, for the first time, proper storage and study facilities together with four galleries, will enable ease of public access besides a changing display of our own treasures.

During the last five years the collection has expanded at a phenomenal rate filling in vital gaps, especially in the field of twentieth-century photography. We have also made it our role to acquire the work of new young photographers. During this period outstanding purchases have included the *œuvre* of Bill Brandt and Cartier-Bresson, the albums of Paul Martin, besides outstanding photographs by Walker Evans, Paul Strand and Cecil Beaton. There have also been major photographic exhibitions, including *The Land* and the Don McCullin retrospective, and we have toured a selection of our treasures and the entire Cartier-Bresson collection. The continued rapid expansion and consolidation of this national photographic collection with international representation remains a prime objective for the 1980s. Our sole criterion is aesthetic quality so that we have been able to focus our energies on the acquisition of the work of the greatest masters both past and present. This book, compiled by Mark Haworth-Booth, the Assistant Keeper in charge of the collection, provides in microcosm an index of the achievement to date.

ROY STRONG
Director
February 1981

INTRODUCTION

ARE THERE now more photographs in the world than bricks? Most of us add to the billions of photographs in existence, and while we would have trouble turning out a decent hand-made brick, we can and do turn out technically good – even perfect – photographs. Technology has professionalized the amateurs; children are masters of one-step photography. This is the result of a breathtaking technical development embracing chemistry, optics and electronics. The pace of this development is always making fools of would-be humourists. Seventy-five years ago the photographer Edward Steichen permitted himself this fantasy:

Someday there may be invented a machine that needs but to be wound up and sent roaming o'er hill and dale, through fields and meadows, by babbling brooks and shady woods – in short, a machine that will discriminatingly select its subject and, by means of a skilful arrangement of springs and screws, compose its motif, expose the plate, develop, print, and even mount and frame the result of its excursion, so that there will be nothing for us to do but to send it to the Royal Photographic Society's exhibition and gratefully to receive the 'Royal Medal'.

Frames and medals apart, photography has done all this – although the machinery photographed in outer space rather than among babbling brooks. In addition to the science fiction miracles of photographic picture-making and the abundance of the amateurs, there is also a vast output from the professional sector in which men and women make photographs day in and year out. News, fashion, editorial, advertising, portrait, science and history. Finally, there is the elusive group of born graphic artists who have chosen to use cameras, jumping jacks who may turn up anywhere. Cameras nowadays may have achieved the facility of making instant discriminations – but how do *we* make any critical or aesthetic distinctions in this prodigious and apparently chaotic ocean of activity?

In gold letters above the entrance to the Victoria and Albert Museum is a message from Sir Joshua Reynolds: 'The Excellence of Every Art Must Consist in the Complete Accomplishment of Its Purpose'. This maxim, perhaps, seems to be all-inclusive to the point of becoming bewildering – like the contents of the Museum itself – and yet it's a good starting point. It serves the great virtue of insisting on distinctions among kinds, types and species. However mercurial and pervasive photography is it can at least be considered as the sum of many different kinds. Although the categories seem to spill over from one to the next with alarming ease, and drastic revaluations are always occurring, Reynolds does give us a start.

Henry Cole, first Director of the South Kensington Museum – the ancestor of the Victoria and Albert Museum – had no doubt about the uses of photography. He set up a museum photographic service in 1856 and said that photographs could provide 'specimens of the highest objects of art at the cheapest possible rate'. By this he meant copies. A princely drawing by Raphael might be valued at the then equally princely sum of £200 but 'by the agency of photography . . . any working man may get it for 5*d*'. The Museum amassed, circulated and sold a huge number of photographs of works of art and architecture – the first true 'Museum without walls'. No one would quarrel with that kind of photograph collecting, not even two of the most interesting early critics of the medium, Lady Eastlake and Charles Baudelaire. Lady Eastlake was the wife of the Director of the National Gallery, who was also first President of the Photographic Society (later the Royal). She was in a good position to know what was going on in photographic circles in the 1850s, and she wrote a splendid article in the *Quarterly Review* in 1857. She had the great advantage of being young when photography was young. She was photographed by Hill and Adamson in the 1840s. Their calotypes made her feel that the spirit of Rembrandt had revived. But by the mid 1850s, photography had become 'a household word and a household want, used alike by art and science, by love, business and justice'. Photography had rapidly reached the stage of mass-production and had gained a technical exactness unknown to the early calotypists. She asked the question as to 'How far photography is really a picturesque [meaning art] agent?' And she had to reply that, while photography

had become more exact, it had also become less true. In portraiture the broad suggestion of form had been replaced by a fussy accumulation of secondary detail: 'Every button is seen – piles of stratified flounces in most accurate drawing are there – but the likeness to Rembrandt and Reynolds is gone!' The imaginative youth had become a dry and materialistic adult.

Lady Eastlake therefore debarred photography from the name of art but this did not lessen her respect for the medium. She regarded art as in any case a minority interest but in the public at large she recognized a 'craving, or rather necessity, for cheap, prompt, and correct facts' which photography admirably fulfilled.

Writing at the same date in Paris, Charles Baudelaire agreed. Baudelaire saw photography as actually threatening true art unless it was put firmly in its place. 'Let it rescue from oblivion those tumbling ruins, those books, prints and manuscripts which time is devouring, precious things whose form is dissolving and which demand a place in the archives of our memory – it will be thanked and applauded. But if it is allowed to encroach upon the domain of the impalpable and the imaginary, upon anything whose value depends solely upon the addition of something of a man's soul, then it will be so much the worse for us.' He saw the genuine poetry of art being driven out of existence by the prose of photography, 'thanks to the stupidity of the multitude which is its natural ally'.

However, fine photographs *were* being exhibited, collected and admired in the 1850s. Right at the beginning of the connoisseurship of photography is a wealthy English clergyman and collector, the Reverend Chauncey Hare Townshend. Townshend bequeathed his collections to the South Kensington Museum and the inventory makes interesting reading. His passion was for precious stones, many of which are now in the Jewellery Gallery of the Victoria and Albert Museum. But when we come to his cabinet of fine prints we move directly from Rembrandt etchings to Roger Fenton's photographs of the Crimean War – among the first war reportages by a photographer – and to magnificent studies of sea and sky made by Gustave Le Gray.

When Townshend was collecting, Fenton and Le Gray were among the very finest printers of photographs. But at the end of the 1850s a wave of commercialization broke on the artist-photographers – Fenton and Le Gray abandon their efforts altogether, while the great Camille Silvy turns his attention, very successfully, to becoming rich as a portrait photographer. It is as if Lady Eastlake and Baudelaire had been believed. And yet one curiosity in the history of photography is that Baudelaire was an ardent supporter of the work of the artist-illustrators Daumier and Constantin Guys, and that they are direct predecessors of the great

photojournalists his country produced sixty years later. When he writes of Guys as the embodiment of the *flaneur*, the dandy, the spectator of all the moods of teeming, modern city life, he is already characterizing the world of André Kertész and Henri Cartier-Bresson. Using the discreet, rapid-action cameras that arrived in the 1920s, Cartier-Bresson came far closer than Guys to the ideal painter of modern life as described by Baudelaire: 'we may liken him to a mirror as vast as the crowd itself; or to a kaleidoscope gifted with consciousness, responding to each one of its movements and reproducing the multiplicity of life and the flickering grace of all the elements of life . . . [a] lover of universal life who enters the crowd as if it were an immense reservoir of electrical energy'.

In a sense a museum is not only a repository of artifacts but a place of historical judgement, a belated court of appeal. Museums now uphold, for example, the claims for photography as a fine art made at the turn of the century by Alfred Stieglitz. His 'Photo-Secession' movement was really secession from the idea that photography is necessarily outside the confines of art. Some justice can be done to the broken careers of misunderstood artists and craftsmen, loops of time can be re-plotted, pictures made in journalistic contexts can be reprieved from the death-sentence of decaying newsprint. After all, museums have time on their side if not on their hands. It is now quite clear that major graphic talents have matured in the last fifty years as much on magazine assignments and in darkrooms as in the traditional ateliers. The opportunities of a Cartier-Bresson, travelling in many parts of the world and with his own precise sense of relevance, helped us all to a sharper sense of history and grace. His generation had special opportunities – but as he himself says, you have to milk the cow a long time to get a little butter. From a career which began in 1929, Cartier-Bresson has chosen an archival set of his pictures that numbers less than four hundred. The Englishman Bill Brandt chose two hundred of his own pictures for the Museum archive from a career which also began fifty years ago. These are modest self-assessments by two remarkable men considering the thousands of photographs they have taken and had printed in magazines: an average of eight good pictures a year for Cartier-Bresson, and four a year for Brandt.

I have pointed out that the Victoria and Albert Museum has a long history of collecting photographs. The foundation of a Department of Prints and Drawings and Photographs comes relatively late in the story and it has come at a time of intense activity in the medium. There is a general fascination which surfaces in films like *Blow Up*, *Girl Friends* and *The Eyes of Laura Mars*, and in novels – notably Paul Theroux's *Picture Palace*. The newspapers astonish us

regularly with saleroom sensations and photography as a new field for fakers.

By what right has photography established itself as part of the mainstream of art? There are several contributory causes. It is clear that fine print-making and acute graphic eloquence have been intermittently present in photography since the beginnings. Fine seeing has usually been allied to fine execution. It is a matter of simple justice to the physical procedures of photography for museums to insist on acquiring the finest possible prints from the finest possible negatives. Which the best prints *are* is a matter of judgement – some photographers have changed their printing style from one decade to another. Besides individual preferences on the part of photographers there is the wider issue of just what kinds of printing paper have been available at a particular time. Platinum coated papers flourished for a generation and became prohibitively expensive when the First World War began its drain of precious metals. The silver content of more recent papers has been in decline since the thirties – possibly the age of silver will follow that of platinum into extinction. So a supposedly precious attitude towards photography is not as irrelevant as it might at first seem.

Almost in direct conflict with this is the view of photography as an authentic popular and democratic art form – accessible, free of mystique, illustrative of the real conditions of life, a treasure-house for historians of society. Certainly the high visual art forms of recent years appear to have abandoned most areas of common ground with anything like a popular audience. Painting has always been assumed to be the main growing stem of the visual arts but the refined abstract investigations of recent decades have been challenged as merely out on a limb. A new generation of critics, curators and museum-goers have looked for 'pictorial moralists' – in Baudelaire's phrase – and been disappointed by official art. The traditions of photojournalism and documentary photography have been thrown into relief and much of the work by painters has seemed relatively tepid or frivolous by comparison. As a new realism returns to painting in the early 1980s, photography is experienced as a huge lungful of fresh air at a time when shallow breathing had become the rule.

There is another strand in this development, again an apparent contradiction. Still photography has been steadily losing its traditional strongholds in mass-information and reporting as every home has gained its television.

Under sheer pressure of the events it flashed to its public, photography was implicitly believed: now it is questioned as to its precise role in communication, interrogated as to its procedures and its conscience. At the same time, TV has released photographers to work in areas in which TV is a giant too bulky and too slow to move in comfort, or too coarse to record with the right finesse. So a still photographer on his own can make intimate records where a television crew cannot follow. Or a photographer can use the sensitivities of his film to make images of exquisite refinement. A photographer can use the new potential of colour film to describe the world around him in a depth of detail no one has been able to achieve before. Or, at a low cost and manoeuvrability for which large corporations are not renowned a photographer can gather his own evidence of contemporary historical actualities – and become independent, truthful and unpopular.

Faced with this richness of production the Museum's reaction must be to attempt to keep all the ramifications of the medium in focus and to collect what is 'exemplary'. A useful word, that, with its suggestion of not just 'an example' but also 'the best example'. A collection of photographs, therefore, may concentrate on the most refined individual fine prints – photography is a form of draughtsmanship, the 'pencil of nature', in Fox Talbot's phrase – but to be true to the social experience of the medium it will represent kinds of eloquence that are useful, curious and even bizarre. As I have said, I believe Lady Eastlake would have changed her mind about the art potential of photography if she had been able to see everything that is available to us. But she did leave a superb definition of this mercurial medium. She thought that photography was 'neither the province of art, nor description, but of the new form of communication between man and man – neither letter, message, nor picture – which now happily fills the space between them'. Whatever emphasis one places on the *art* of photography, that central view demands study, consideration and respect. Photography inherits many traditional roles from the older graphic media but continues to defy easy classification. Is that the secret of its eloquence?

The state of historical knowledge is changing rapidly and offers new perspectives on some photographs illustrated here. Consider for a moment one of Roger Fenton's famous photographs, 'The Valley of the Shadow of Death' (plate 10). This scene from the Crimea seems like a prophecy of the empty No-Man's Land of the First World War. Without the reference to the Tennyson poem, which invoked the 23rd Psalm to mourn the gallant 600, the picture would have little meaning. The elegiac order of Fenton's picture has made it a favourite anthology piece. However, there is something very curious about this order. Let us turn for a moment to H and A Gernsheim's standard work *Roger Fenton, Photographer of the Crimean War* (1954). Fenton wrote home on 24 April 1855 and described his visit to the Valley of the Shadow of Death, so named by the troops because so many

cannon balls from the Russian batteries overshot their target and accumulated in the ruts of the ravine. He had to stop 100 yards short of the best camera position because shells were still falling into the valley. Even where he did set up his camera one ball came over and rolled to a halt at his feet (he put it in his Photographic Van as a souvenir): 'After this no more came near, though plenty passed on either side. We were there an hour and a half and got *two good pictures*, returning in triumph with our trophies . . .'. The italics are mine. *Two* good pictures? The Gernsheims reproduced one of these (their plate 51) but did not comment on the second. Our plate is the second. In the Gernsheims' picture all of the cannon balls are in the central rut. They might have been there since some forgotten 17th century battle. In our picture about thirty of them are sprinkled artistically across the track to the right. It is, of course, a far more dramatic composition. An empty space is filled with urgent interest – as if the cannon balls are still on the move, arrested only by camera speed (impossible technically at the time, of course). Did Fenton and his servant put them there? Did Fenton, trained as a painter, decide to improve on fact? Or did he wait until the accumulation of wasted cannon balls was right for his idea of the picture? His letter home suggests the first solution. Either way, a species of imaginative manipulation is involved.

E O Hoppé's charming portrait (plate 32) was bought in 1979 as 'A Charlady' and it much resembles photographs he published in the 1920s of 'London Types'. The photographs in the present book are intended to provide a series of contrasts and corres-

pondences. So Hoppé's 'Charlady' seemed to offer pointed contrasts with the Beaton portrait of Marlene Dietrich on the facing page and with Bill Brandt's maid further on. It also seemed to be a wonderful picture of what it is like to be photographed for perhaps the first time – rather like the hopeful, expectant and doubtful frame of mind in which someone might go to a high-class hairdresser. Unfortunately for this theory, a colleague in the Department of Dress pronounced the clothes early 1900s rather than early 1920s, and suggested that this was an actress *playing* a charlady. Our Theatre Museum was divided on the picture but the majority view was that 'she looks too natural for an actress of the period'. The problem was compounded by Hoppé's habit of dressing up friends to look like 'Types' he needed for his books. The historian Terence Pepper eventually provided the answer when he came across this picture reproduced in *The Sketch* for 11 July 1917. The caption: 'In "Limehouse Lounge" Costume: Miss Ivy St Helier as a Coster Girl'. So Hoppé's delightful portrait is not a fabrication at all. It is we who fabricate the meaning of photographs from our own abundant illusions, stereotypes and desires.

The great innovator André Kertész (plates 34 and 41) once exclaimed to me: 'Critics praise my work but don't realize that I *imagine* all my pictures.' Apparently so matter of fact, photographs enable us to imagine them all too well. That is surely part of the unique and complex satisfaction the photographic medium has to offer us.

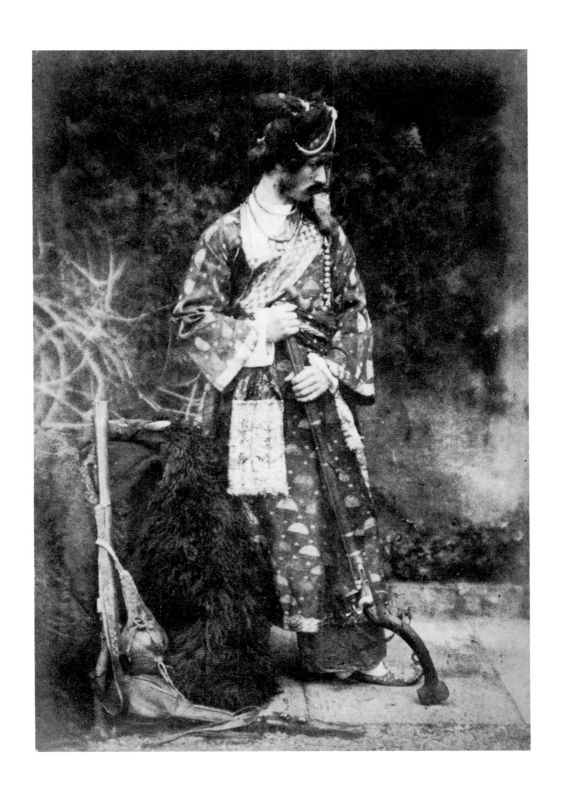

1 *Mr Lane in Indian Dress* 1842–48
David Octavius Hill British, 1802–70
and **Robert Adamson** British 1821–48
Calotype 18.8 × 31.2 3127–1955
Given by Edinburgh Public Libraries

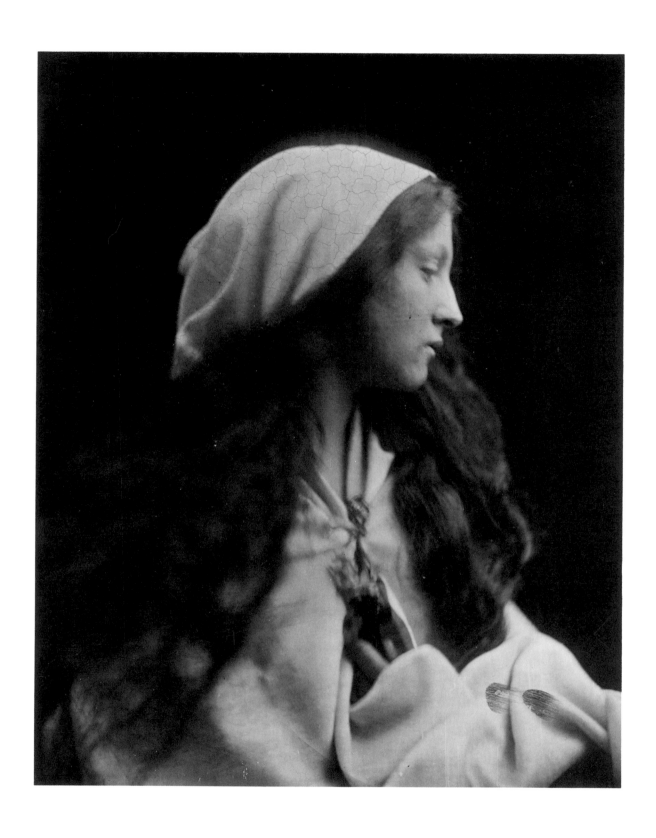

2 *The Dream* (*Miss Mary Hillier*) April 1869
Julia Margaret Cameron British, 1815–79
Albumen 30.3 × 24.2 937–1913
Given by Alan S Cole Esq
Inscribed on the mount: 'Quite Divine' – G. F. Watts. From life registered
Freshwater April 1869. Copyright Julia Margaret Cameron

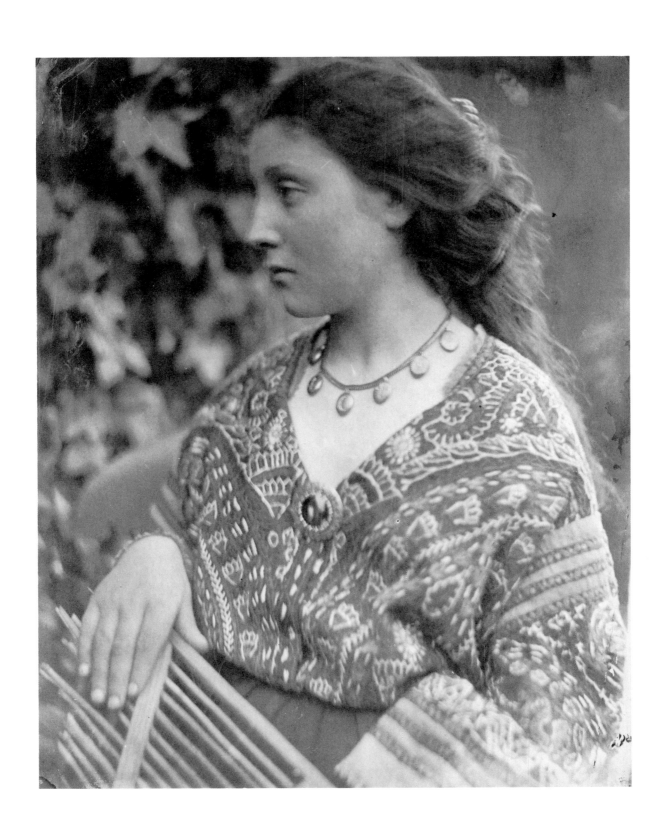

3 *Sappho (Miss Mary Hillier)* *c*1864–5
Julia Margaret Cameron British, 1815–79
Albumen 26 × 21.2 44.753
Acquired from the photographer 1865
Inscribed in pencil on the mount: Sappho

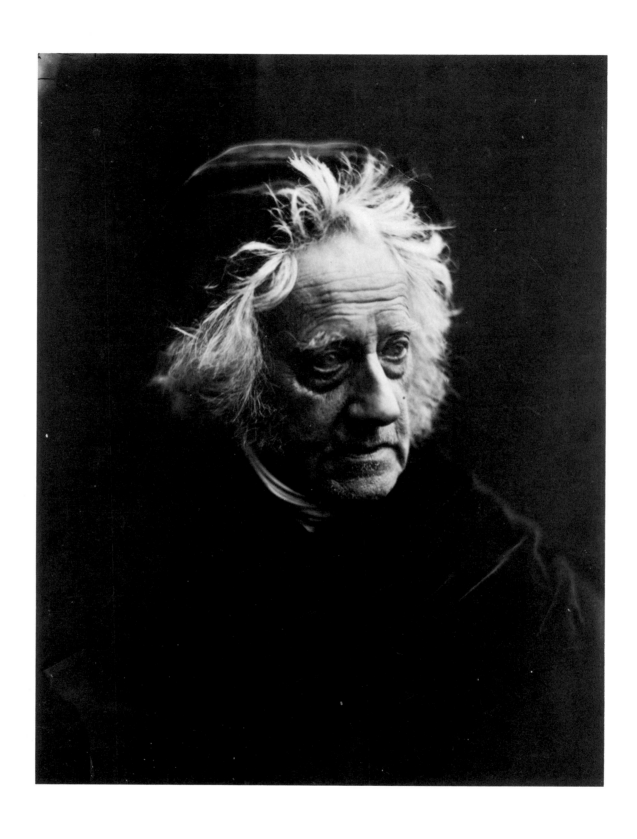

4 *Sir John Herschel* 1867
Julia Margaret Cameron British, 1815–79
Albumen 34.2 × 26.5 930–1913
Given by Alan S Cole Esq
Inscribed on the mount: From life at his own residence Collingwood 1867

5 *The First of September* c1855
William Henry Lake Price British, c1810–96
Albumen 30 × 25 36.375
Probably acquired from the photographer, mid-1850s
Inscribed on the mount in pencil: The 1st of September, by Lake Price

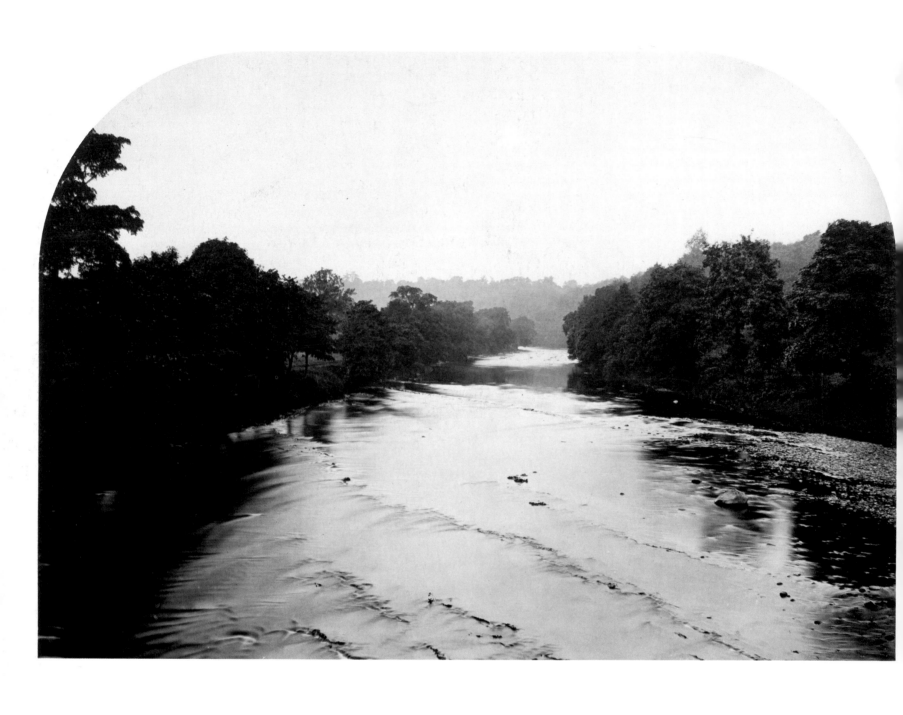

6 *Up the Hodder, Near Stonyhurst* 1858
Roger Fenton British, 1819–69
Albumen 30.7 × 43.2 323–1935
Given by Miss W M A Brooke 1935
Inscribed on the mount in pencil with the title: No. 39
Lithographed: Photographed by Roger Fenton

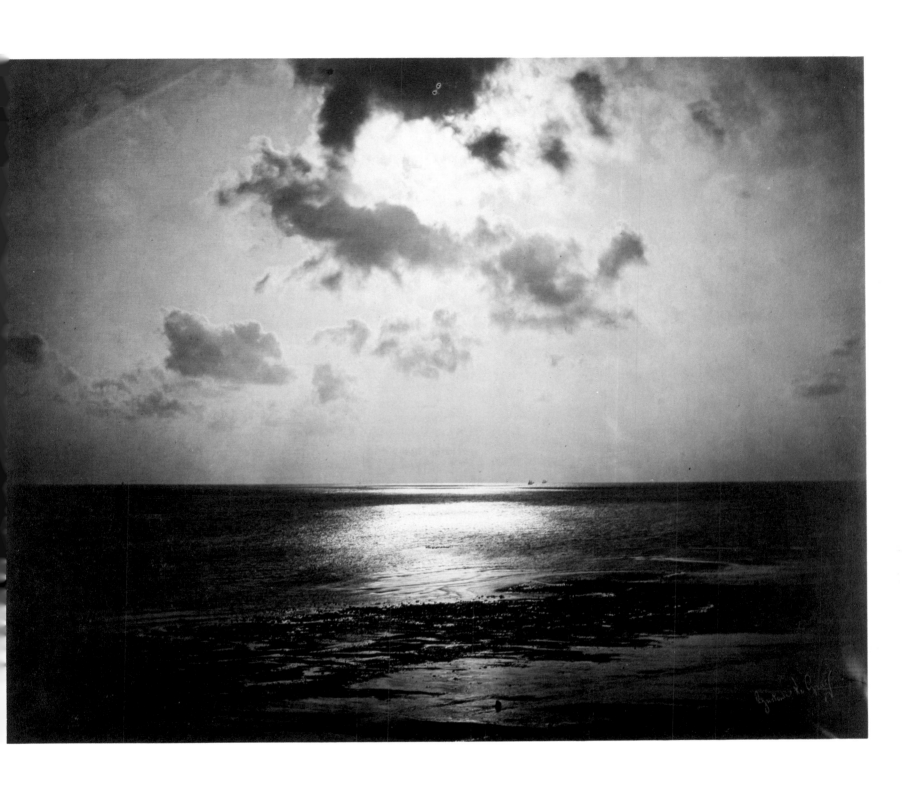

7 *Seascape with Cloud Study* 1856
Gustave Le Gray French, 1820–62
Albumen 32.6 × 43.00 67998
Townshend Bequest 1868
Facsimile signature stamped in red ink

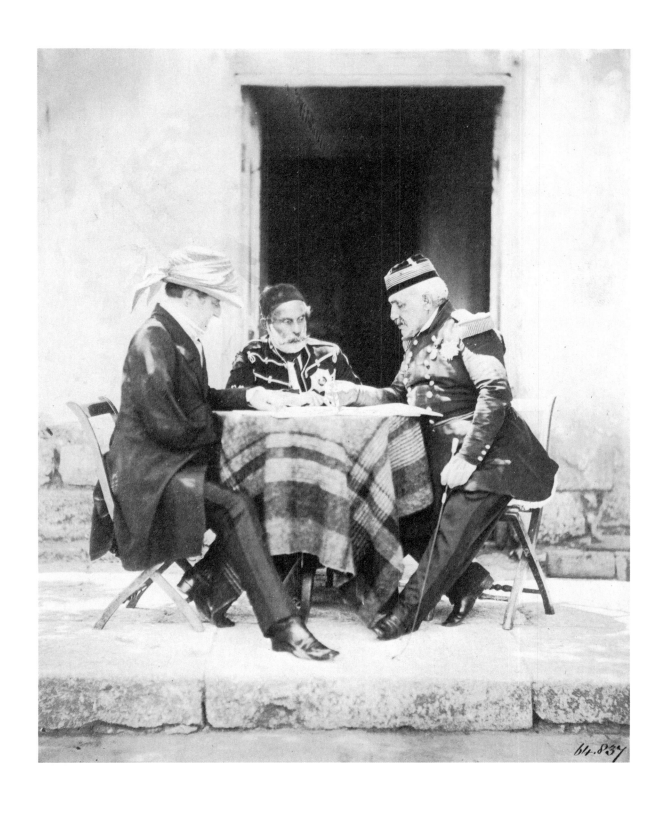

8 *The Council of War: Lord Raglan, Omar Pasha and General Pelissier*
7 June 1855
Roger Fenton British, 1819–69
Salt print from wet collodion negative 18.8 × 15.6 64.837
Townshend Bequest 1868

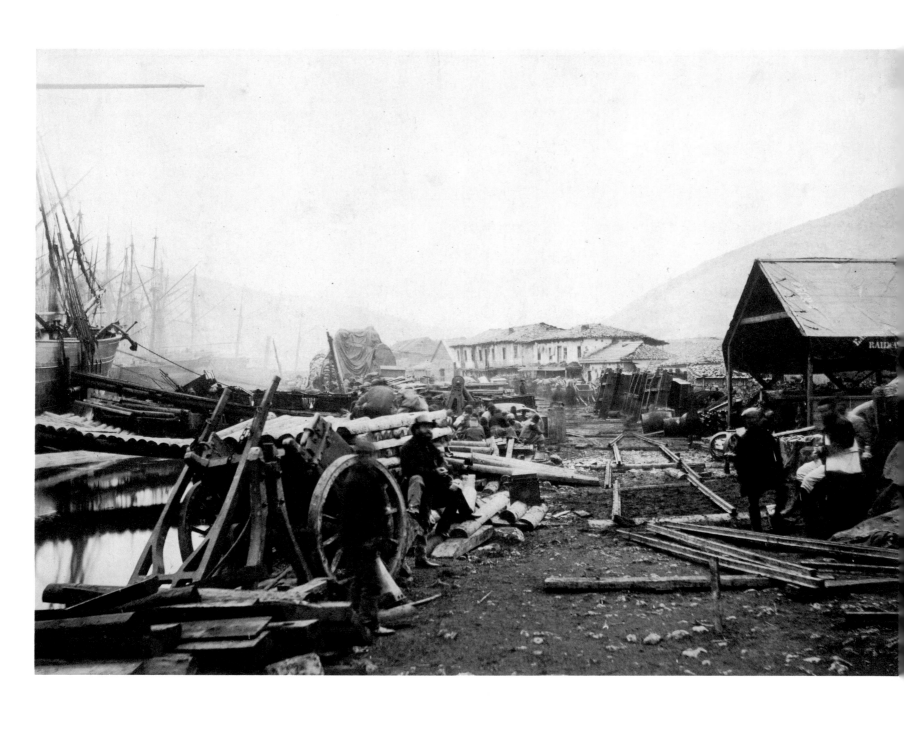

9 *Landing Place, Railway Stores, Balaklava* 1855
Roger Fenton British, 1819–69
Salt print from wet collodion negative 27.0 × 36.7 64.851
Townshend Bequest 1868
Title engraved on mount

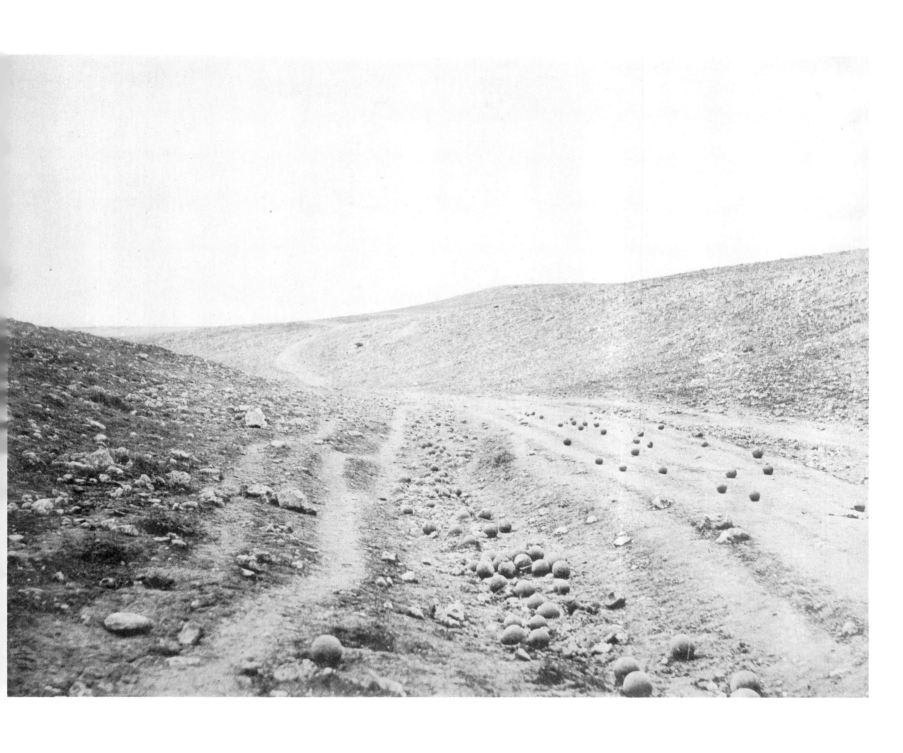

10 *The Valley of the Shadow of Death* 1855
Roger Fenton British, 1819–69
Salt print from wet collodion negative 25.5 × 34.4 64.856
Townshend Bequest 1868

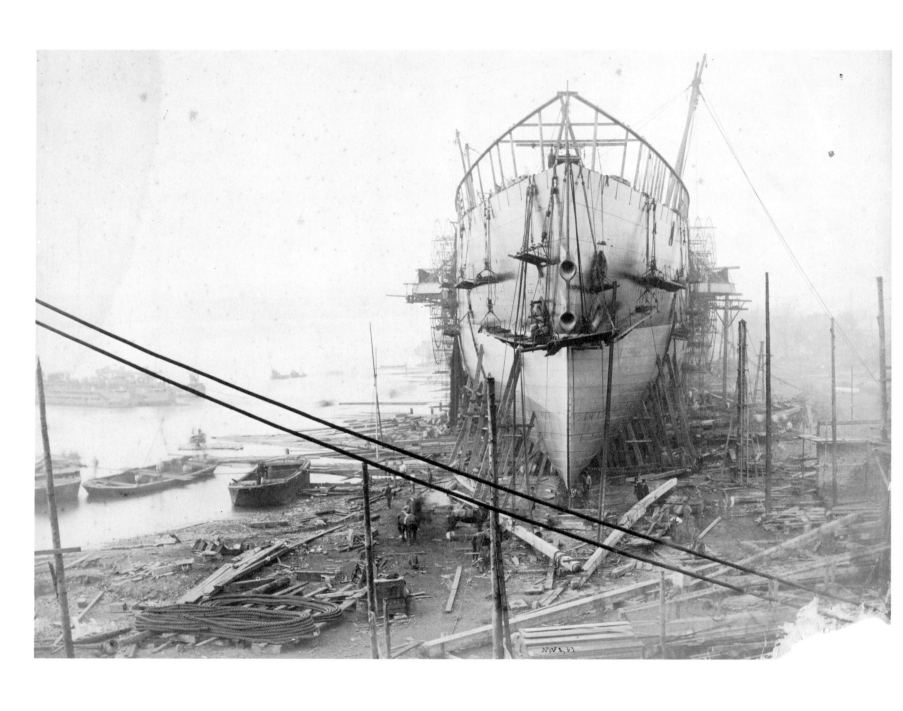

11 *The Great Eastern: bow-on view* 1857
Robert Howlett British, died 1858
Albumen 19.2 × 27.6 250–1979
Purchased 1979
Dated in negative: Nov. 2, 57

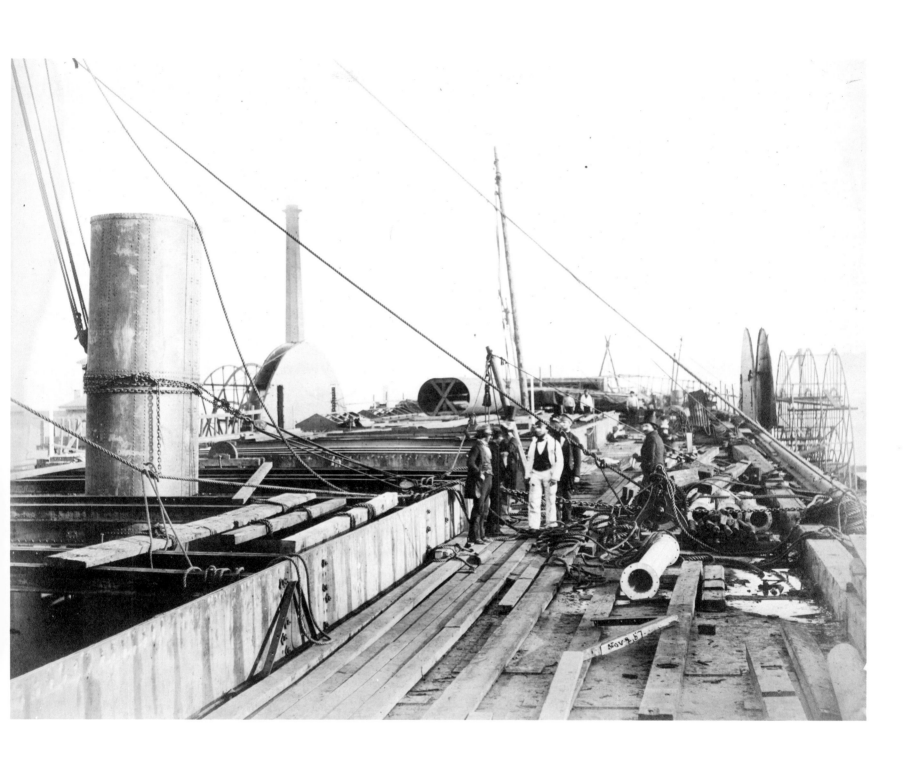

12 *The Great Eastern: view of deck* 1857
Robert Howlett British, died 1858
Albumen 26.6 × 35.9 249–1979
Purchased 1979
Dated in negative: Nov. 2, 57

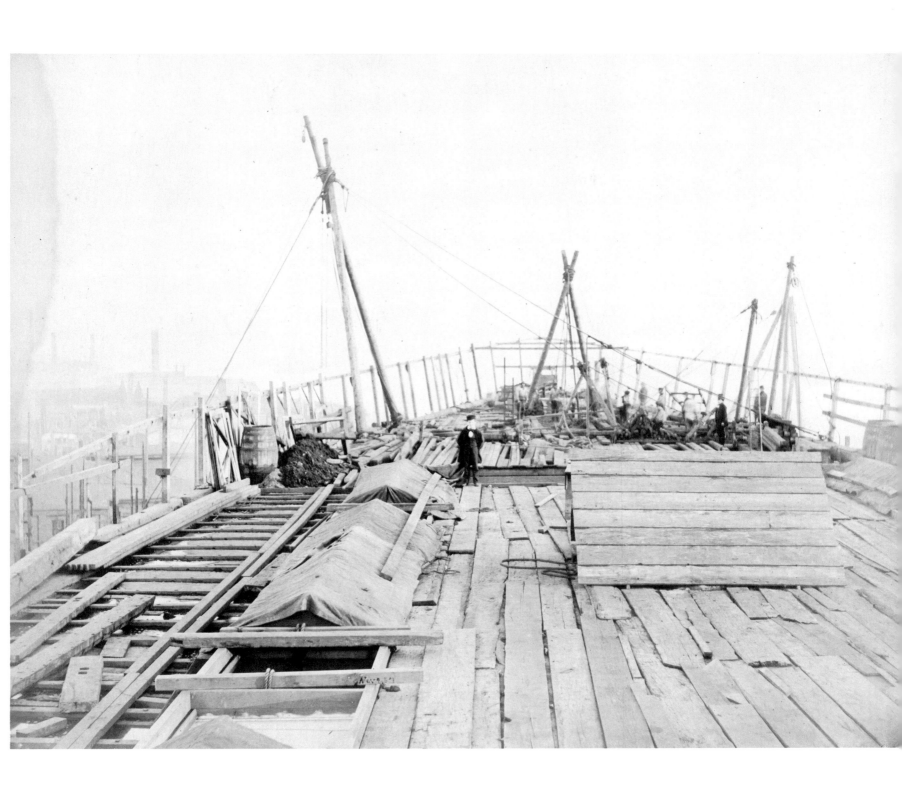

13 *The Great Eastern: view of deck* 1857
Robert Howlett British, died 1858
Albumen 24.8 × 34.9 251–1979
Purchased 1979
Dated in negative: Nov. 2, 57

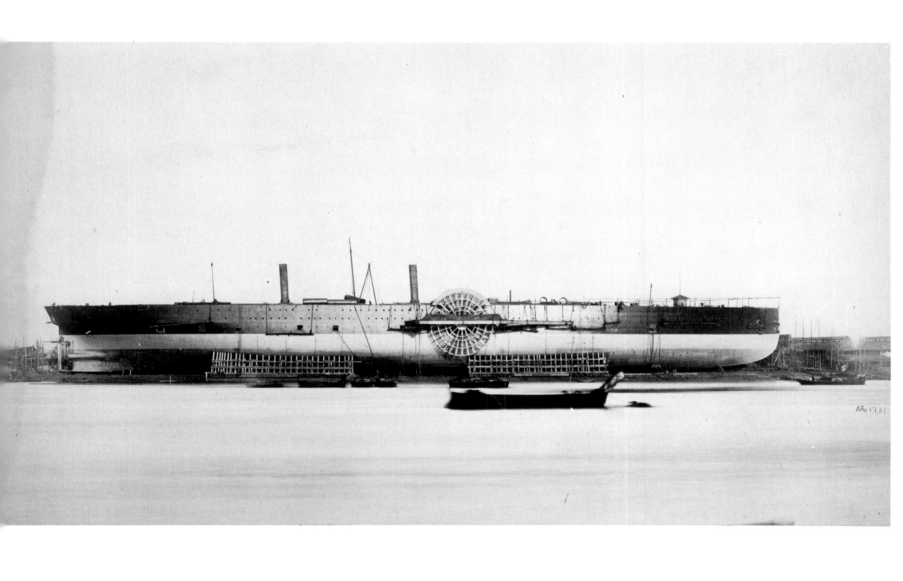

14 *The Great Eastern: elevation from mid-Thames* 1857
Robert Howlett British, died 1858
Albumen 19.2 × 36.9 248–1979
Purchased 1979
Dated in negative: Nov. 17, 57

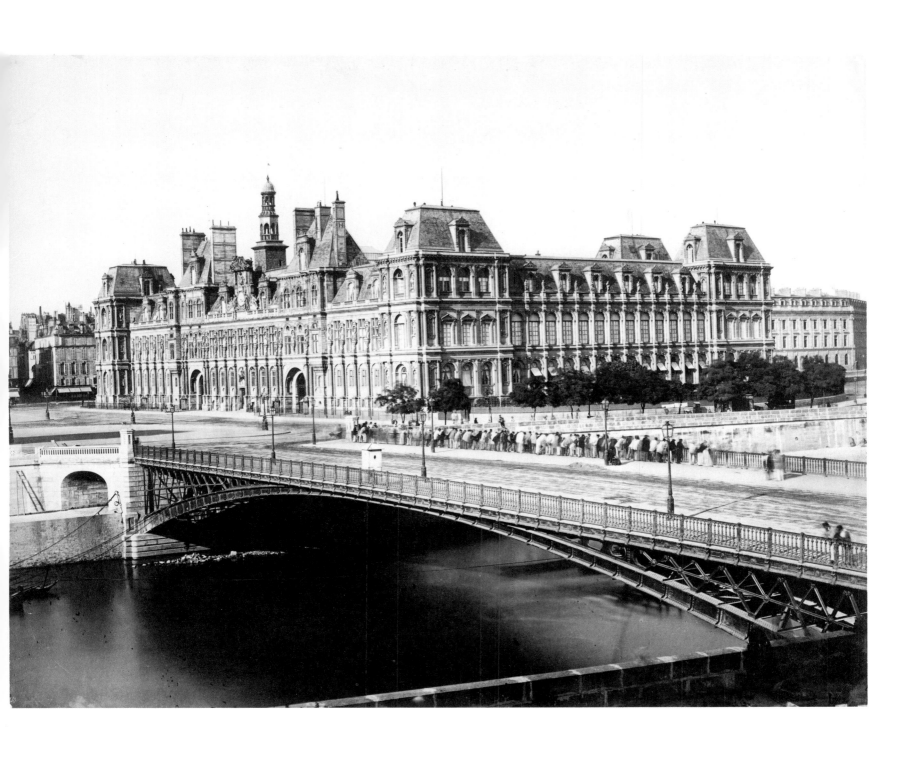

15 *Hôtel de Ville and Pont d'Arcole, Paris c*1860
Edouard Baldus French, 1820–82
Albumen print from wet collodion negative 32.2 × 43 57.029
Purchased from the photographer 1868
Inscribed on mount in pencil: Paris. Hôtel-de-Ville

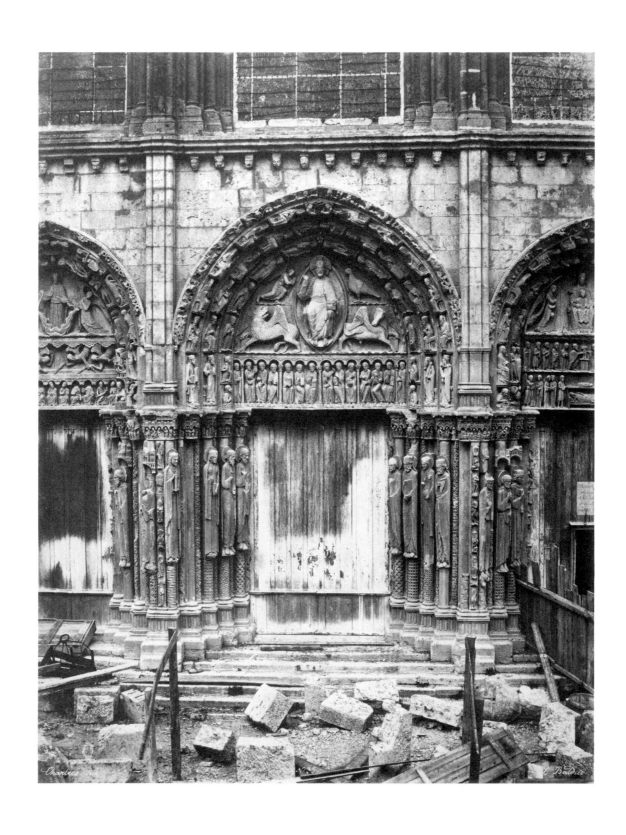

16 *The Royal Portal, Chartres Cathedral c*1855
Edouard Baldus French, 1820–82
Salt print from waxed paper negative 44.5 × 34.3 35 833
Received from the Architectural Museum 1864
Inscribed in the negative: Chartres. Porte. E. Baldus

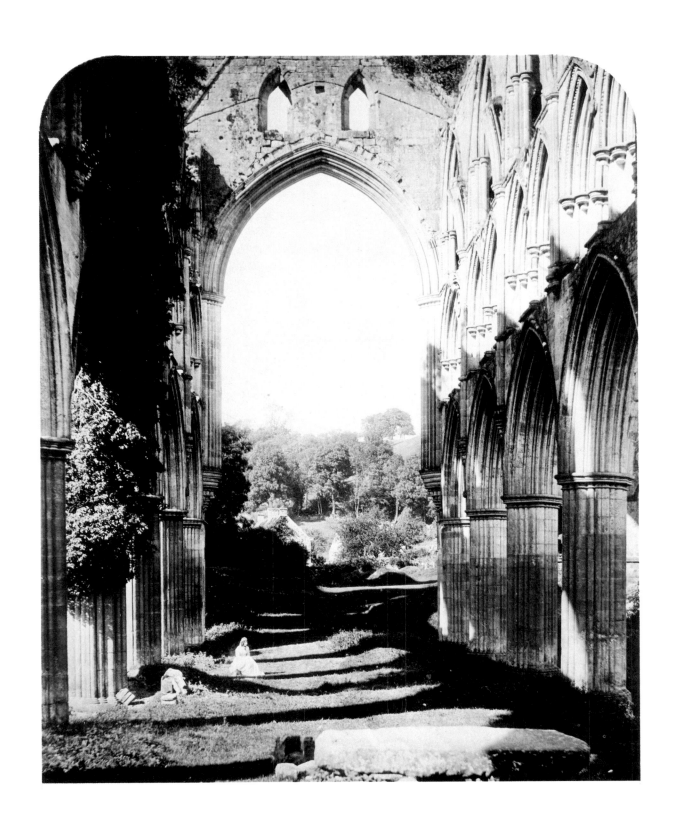

17 *Rievaulx Abbey, Yorkshire* 1854
(negative, print made 1856–60?)
Roger Fenton British, 1819–69
Albumen 34.3 × 27.9 12–1978
Provenance unknown; found in Department 1978
Lithographed on mount: Photographed by Roger Fenton

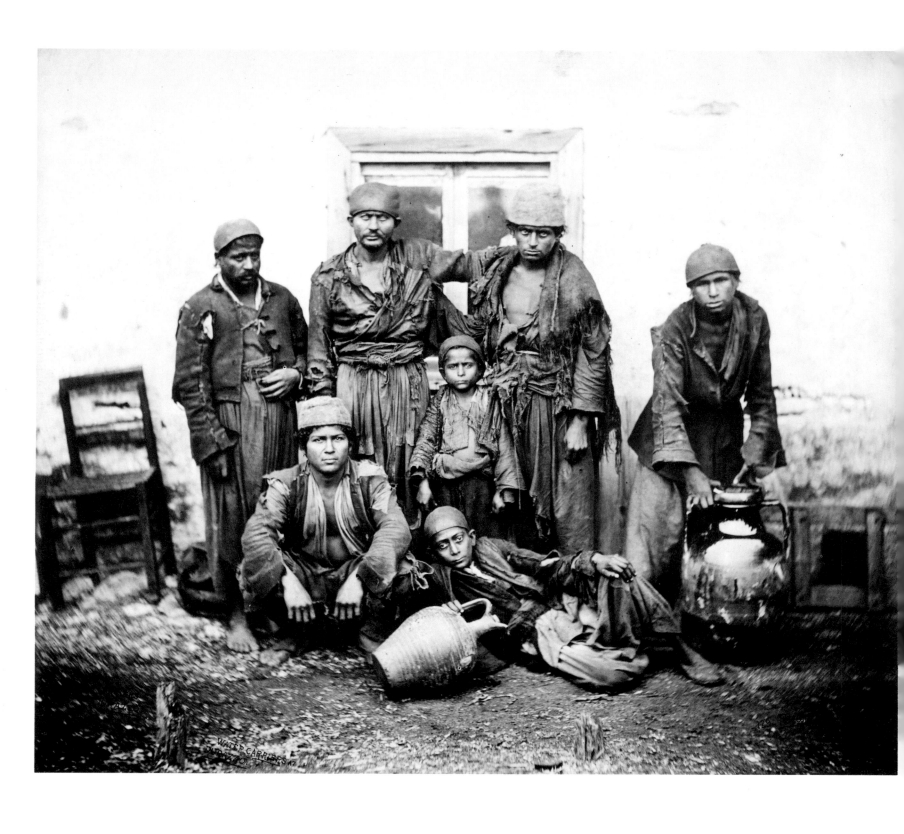

18 *Gypsy Oil (or Water) Carriers, Durazzo, Albania* 1862
Francis Bedford British, 1816–94
Albumen 21.0 × 25.1 53.770
Purchased 1867
Inscribed in negative: Water Carriers at Durazzo
Inscribed in pencil on mount: Gypsy Oil Carriers. Durazzo

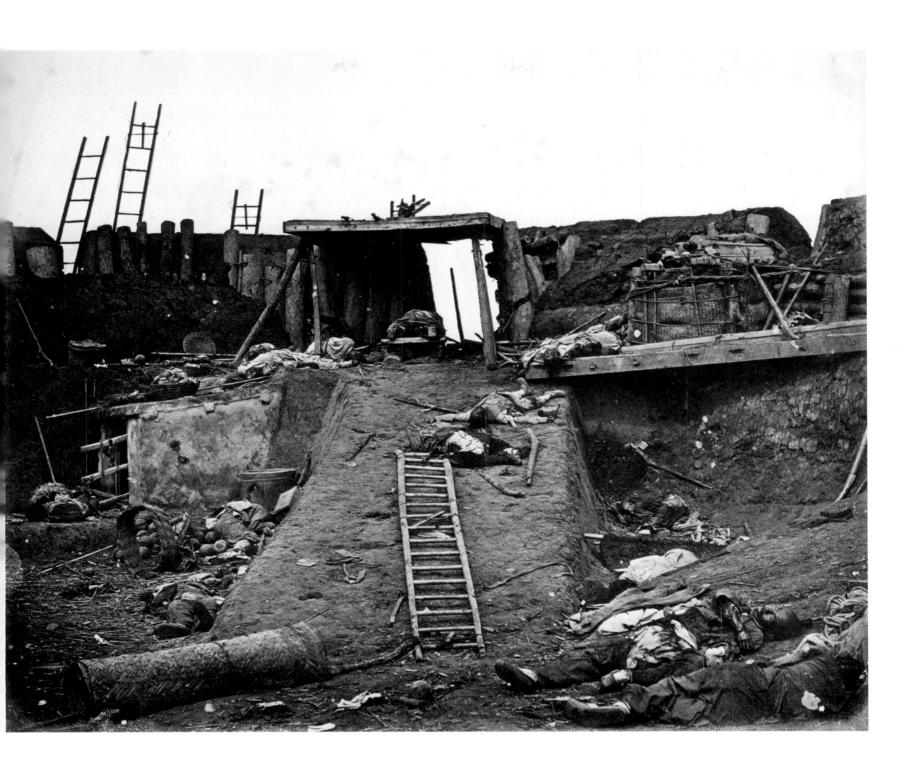

19 *Interior, Great North Fort, Taku 21 August* 1860
Felice A Beato Italian, active 1855–85
Albumen 23.8 × 30.0 140–1975
Purchased 1975 (from an album of 52 photographs: X.872)

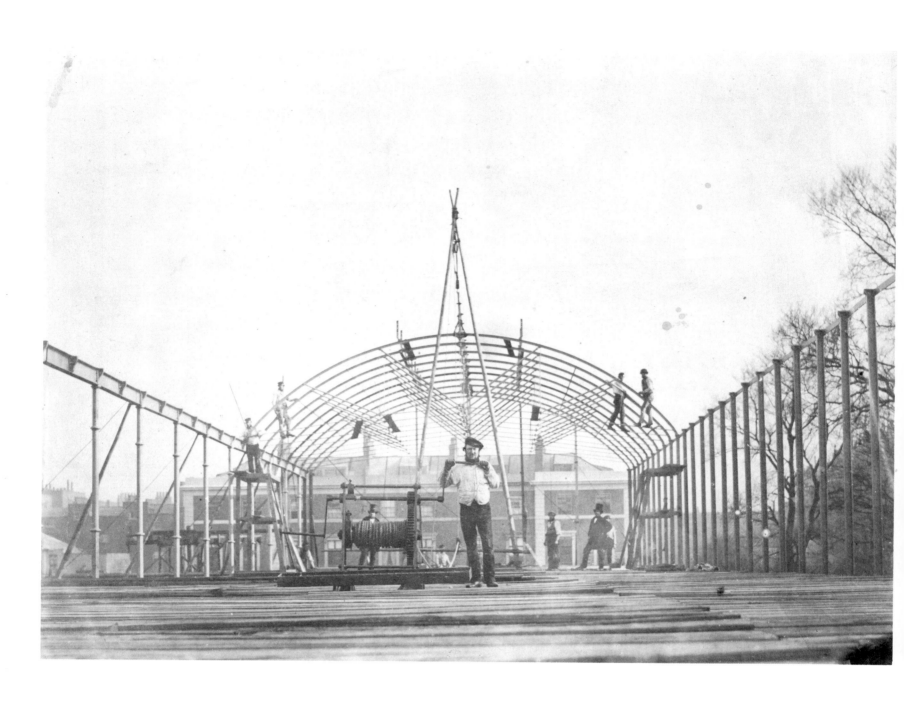

20 *Construction of the South Kensington Museum – Progress of Roof* 1856
Lance Corporal B L Spackman British, active 1855–c1870
Salt print from wet collodion negative 16.2 × 22.6 34.966
Taken for the South Kensington Museum
Inscribed on mount: Progress on Roof on 7 April 1856 Lance Corpl.
B L Spackman RSM 1856

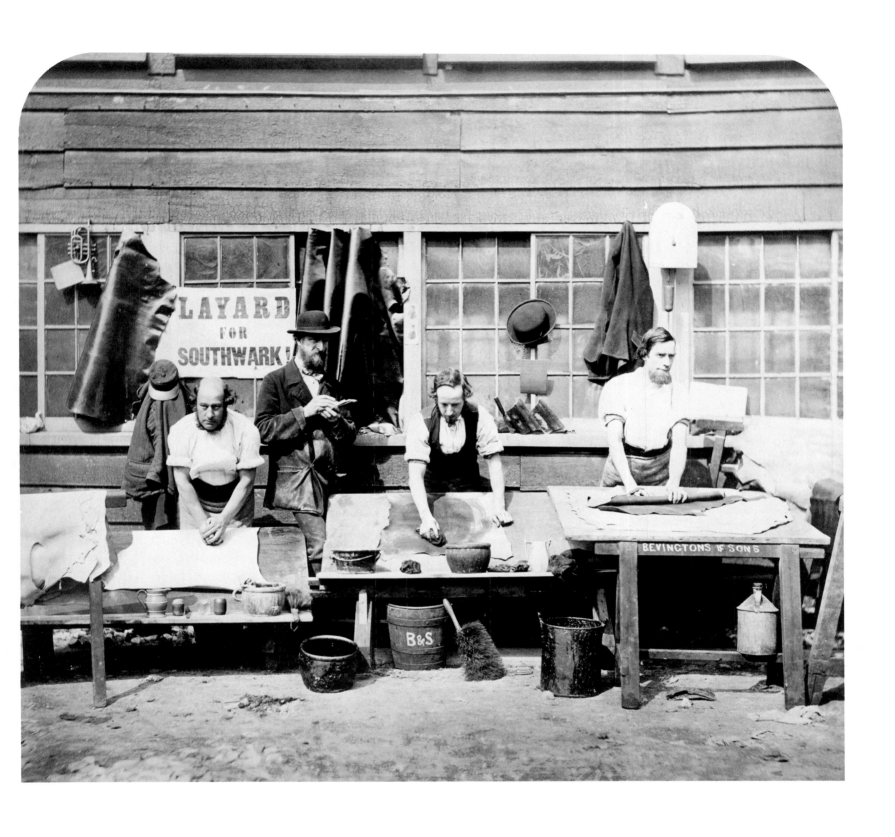

21 *Leather workers in Bermondsey* 1862
Geoffrey Bevington British, active 1860s
Albumen 38.7 × 44.2 A.P.9–1863
Acquired from the photographer 1863
Engraved inscription on mount: Bevington & Sons, Neckinger Mills,
Bermondsey, SE4. Finishing Skivers and Persians for hat linings and
boot purposes

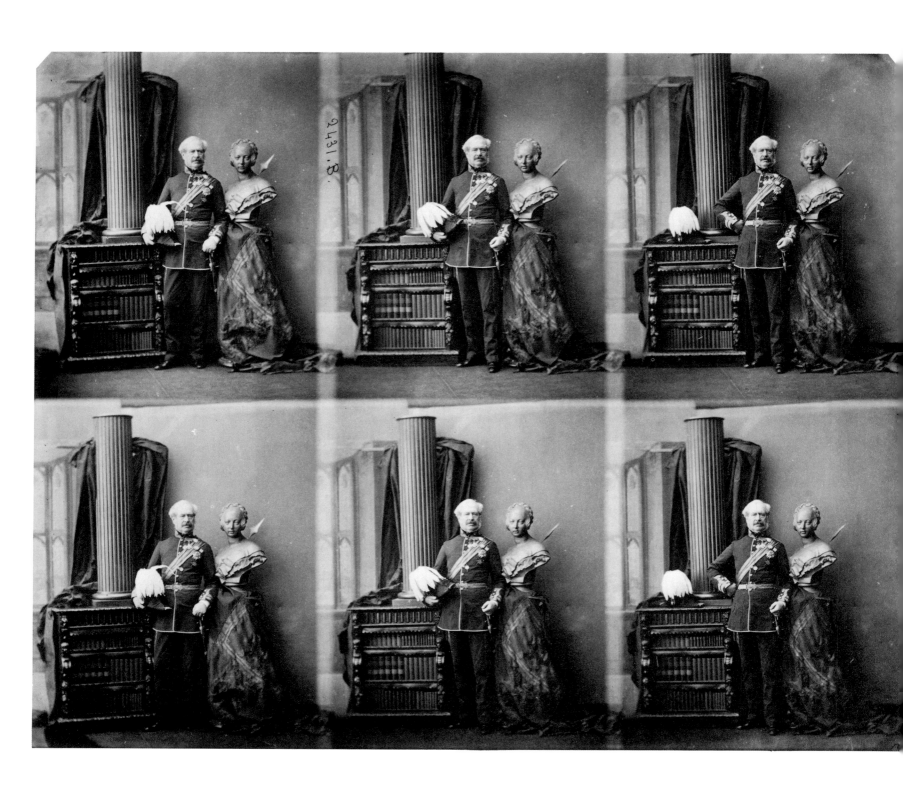

22 *Major General Wylde* 9 March 1860
Camille Silvy French, active *c*1858–69
Albumen 19.5 × 24.5 488–1979
Bequeathed by Guy Little
Inscribed in negative: 2431.B

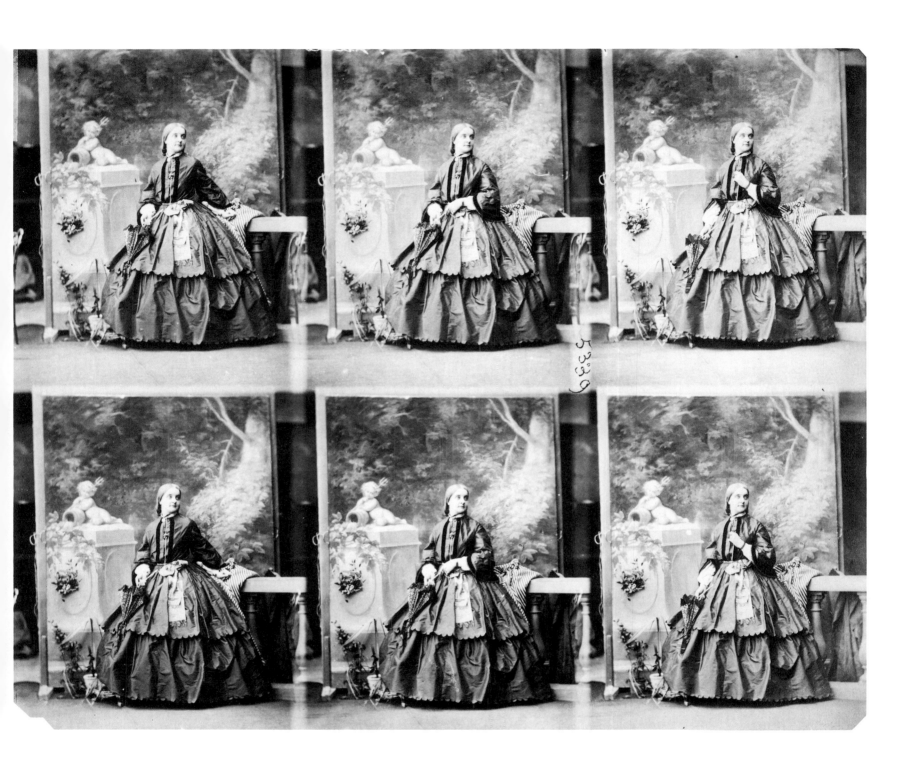

23 *Miss MacGregor* 5 August 1861
Camille Silvy French, active *c*1858–69
Albumen 19.5 × 24.5 487–1979
Bequeathed by Guy Little
Inscribed in negative: 5339

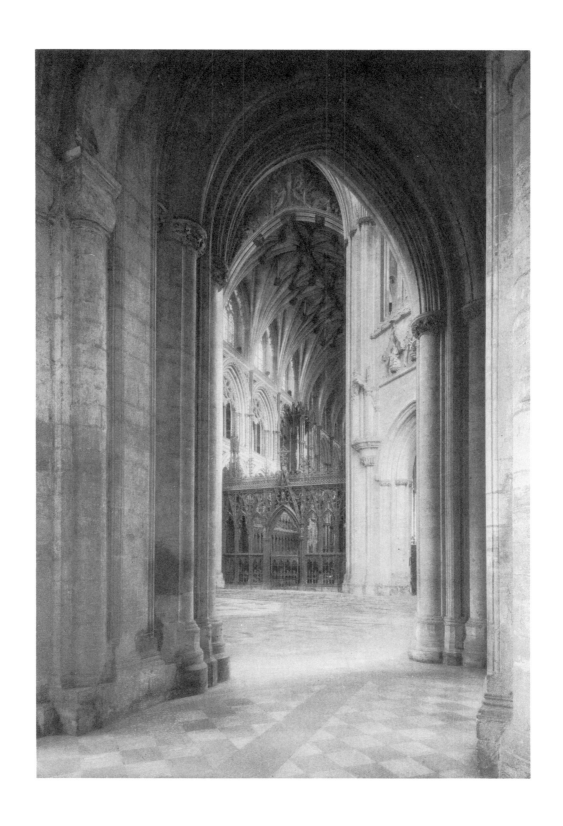

24 *Ely Cathedral: The Octagon* 1890s
Frederick H Evans British, 1853–1943
Photogravure 20.3 × 13.9 596–1900
Given by the photographer
Photographer's monogram in blind-stamp on mount

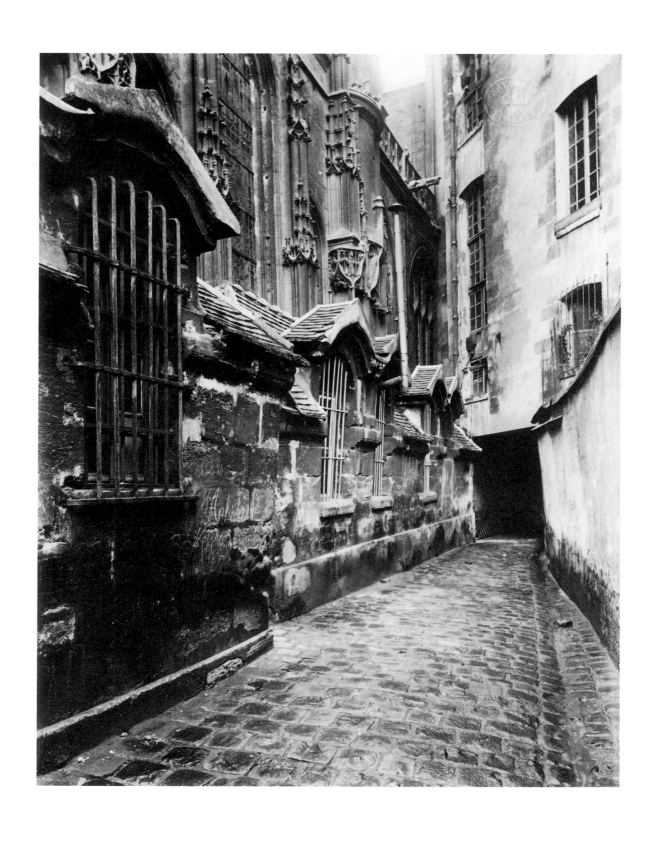

25 *Exterior of the Church of St Gervais, Paris c*1900
Eugène Atget French, 1857–1927
Albumen 21 × 16.7 224–1903
Purchased from the photographer
Stamped on photograph: National Art Library

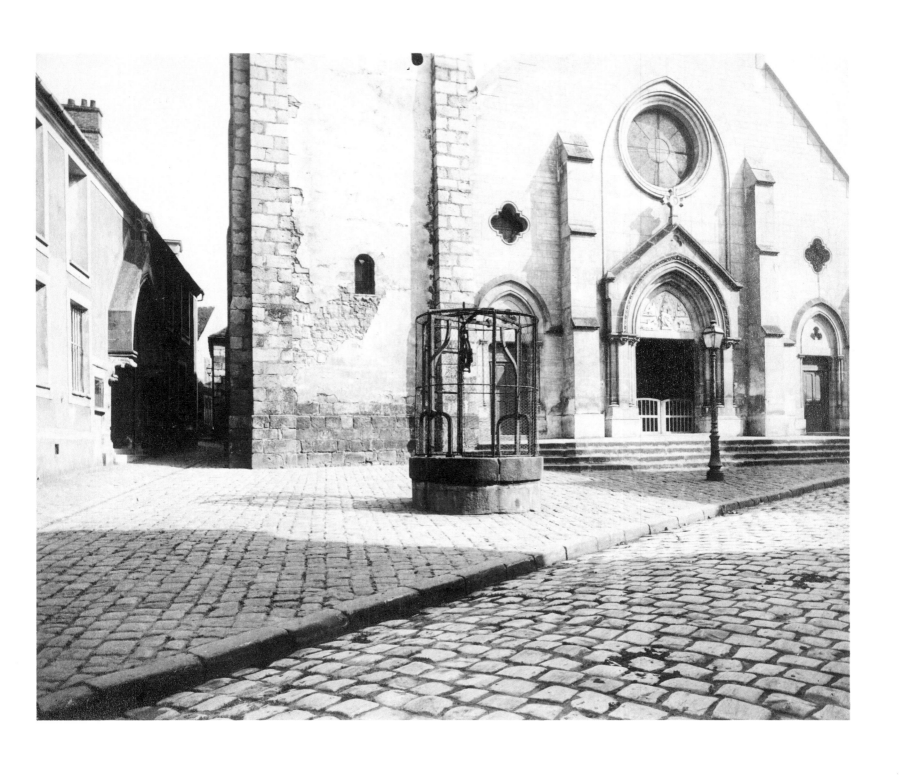

26 *Montlhéry: Church and Well* c1900
Eugène Atget French, 1857–1927
Albumen 17.5 × 21.5 2227–1903
Purchased from the photographer
Stamped on photograph: National Art Library

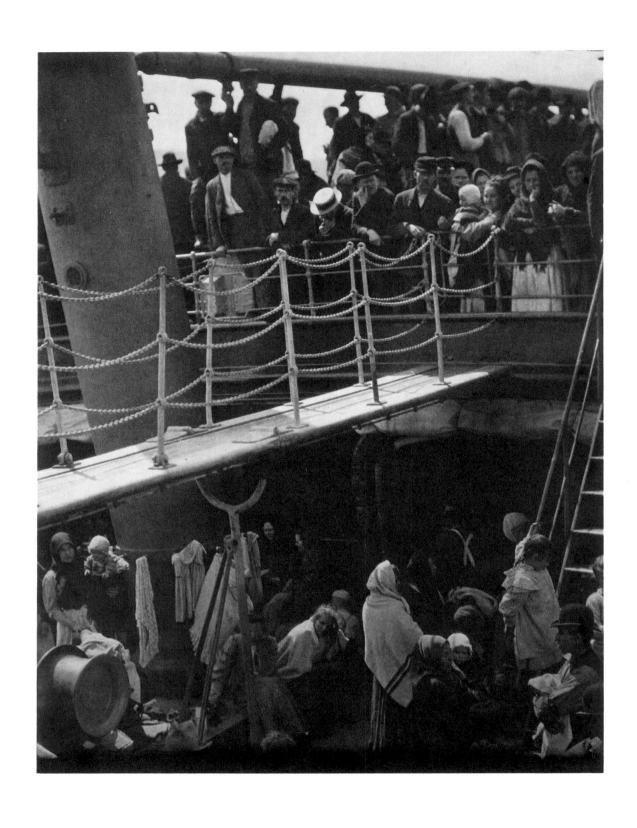

27 *The Steerage* 1907
Alfred Stieglitz American, 1864–1946
Photogravure 32.5 × 25.7 85,1–1978
Purchase

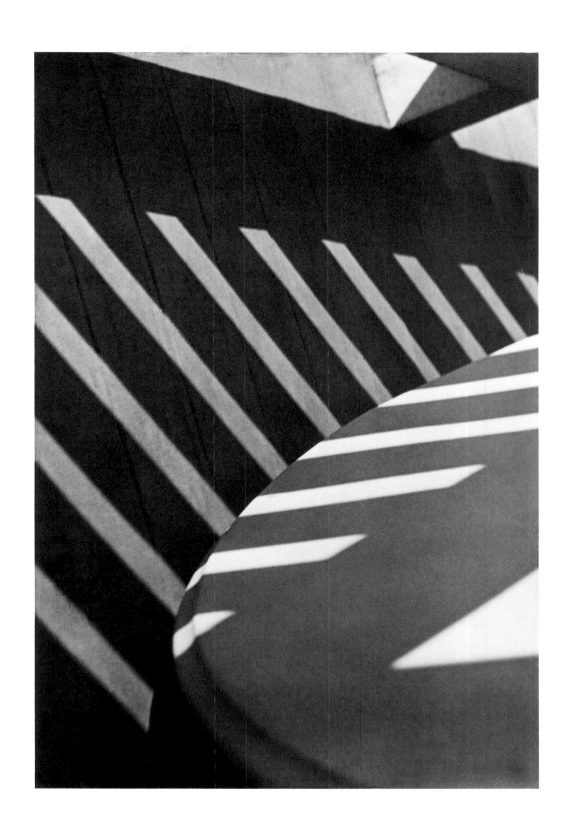

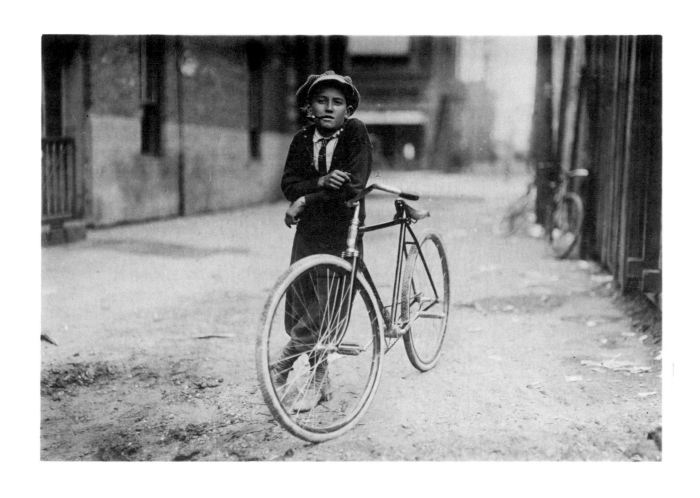

29 *Messenger Boy, Waco, Texas* 1913
Lewis W Hine American, 1874–1940
Silver print 11.2 × 16.3 46–1977
Purchase

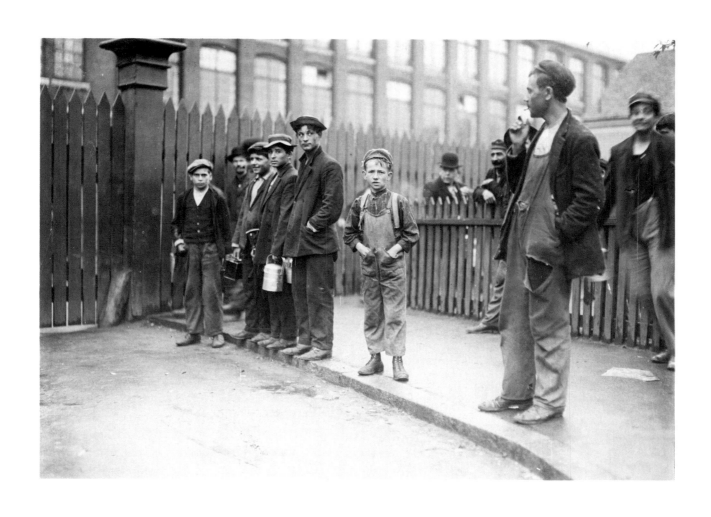

30 *Boys going to work, Warren, Rhode Island* 1909
Lewis W Hine American, 1874–1940
Silver print 11.6 × 16.8 44–1979
Purchase

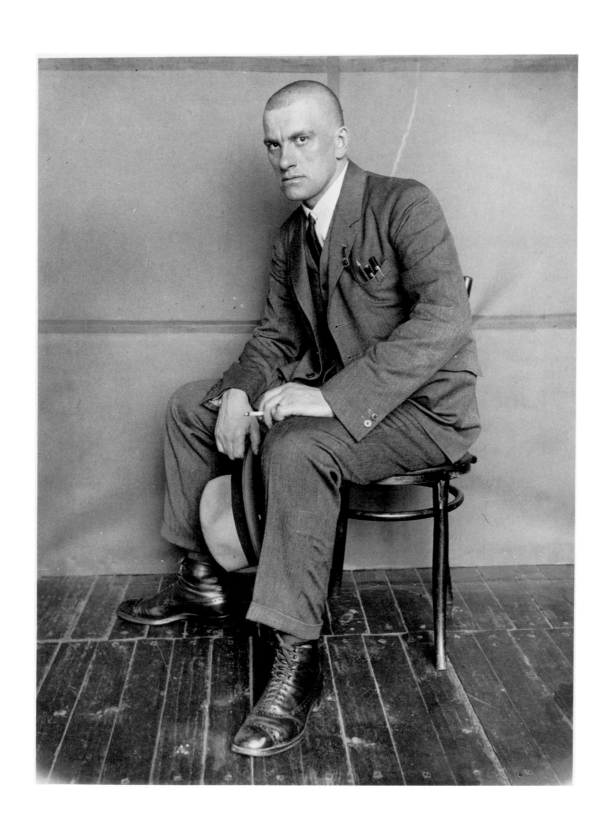

31 *Vladimir Mayakovsky* 1924
Alexander Rodchenko Russian, 1891–1956
Silver print (1960s?) 29.2 × 21.5 654–1980
Given by Varvara Rodchenko

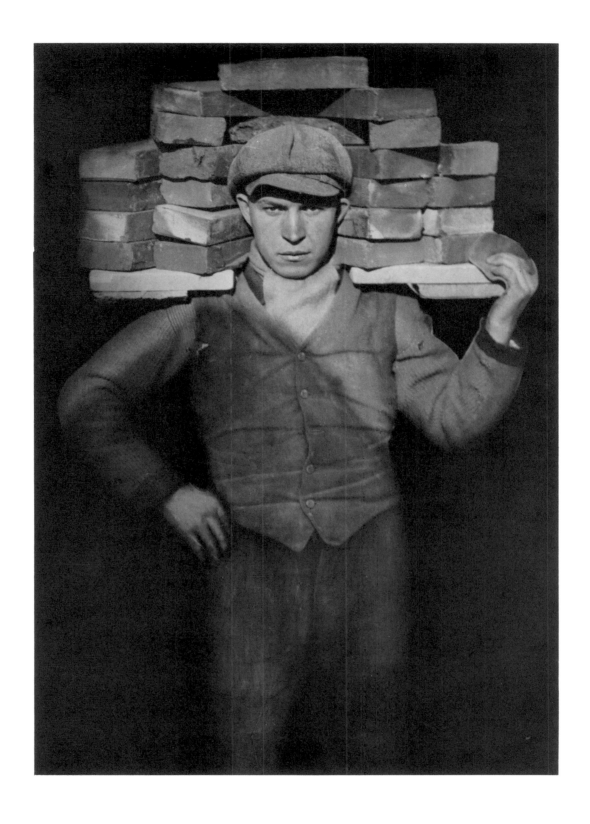

32 *The Hodcarrier* 1929
August Sander German, 1876–1964
Silver print by Gunther Sander from the original negative (1970s)
24.7 × 17.8 139–1979
Purchase

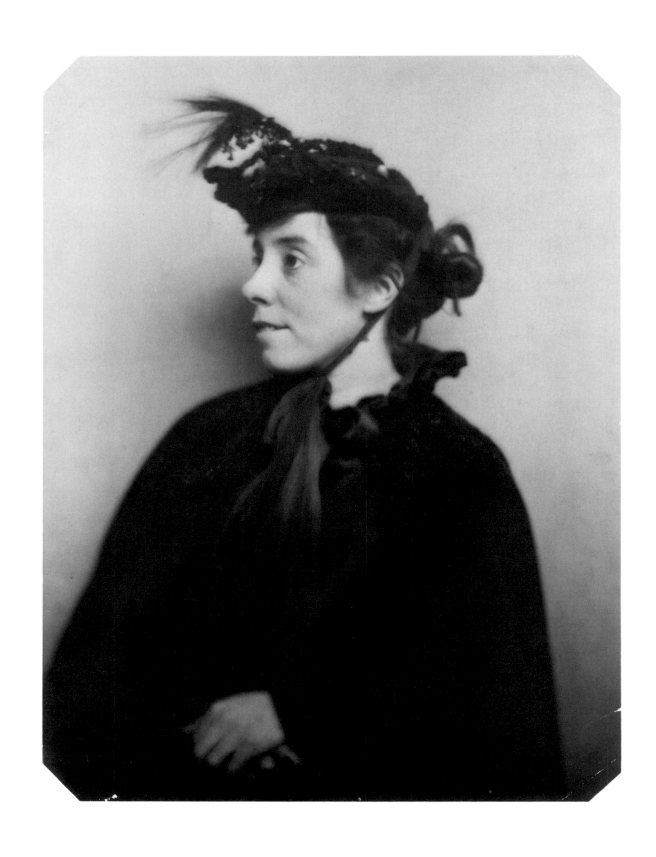

33 *Miss Ivy St Helier as a Coster Girl* 1917
E O Hoppé English born Germany, 1878–1972
Silver print 29.9 × 23.2 497–1979
On reverse: stamp of Hoppé's New York studio
Purchase

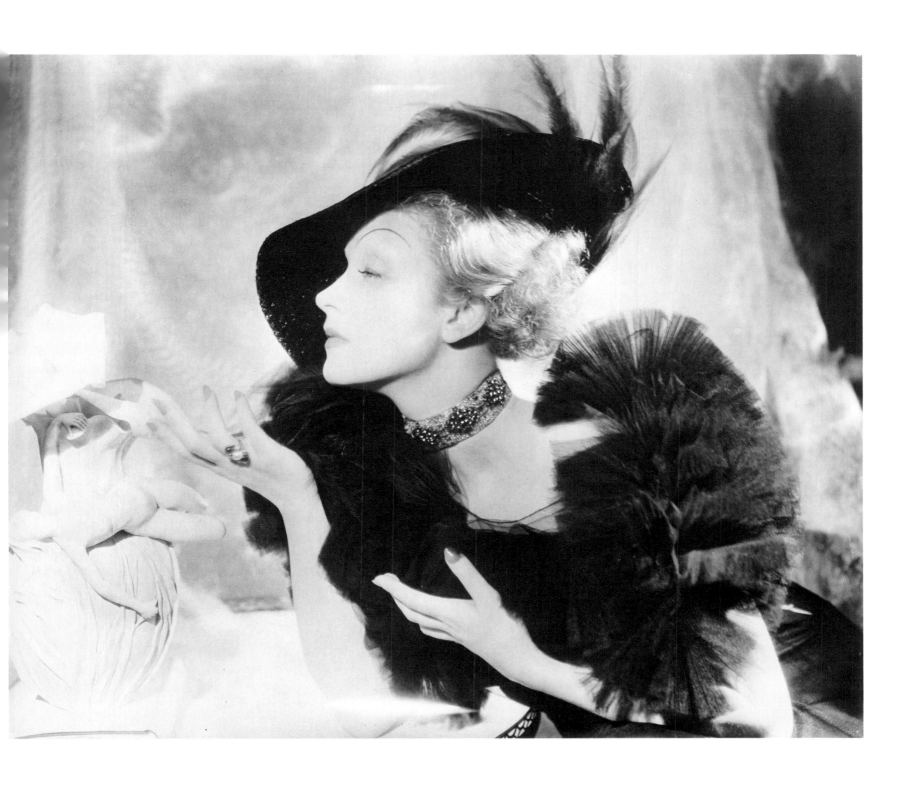

34 *Marlene Dietrich* 1935
Sir Cecil Beaton British, 1904–1980
Silver print 30.8 × 39 963–1978
On reverse: photographer's stamp and Beaton Studio/Sotheby Parke
Bernet stamp (Reproduced by courtesy of Sotheby's Belgravia)
Purchase

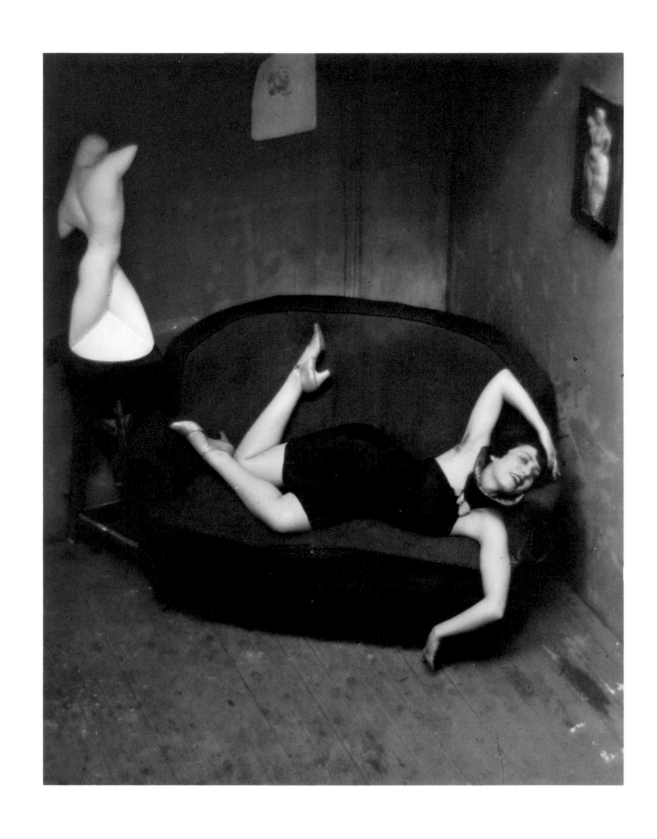

35 *Satiric Dancer* 1926
André Kertész American, born Hungary 1894
Silver print (early 1970s) 24.6 × 19.5 210–1976
Purchase

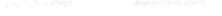
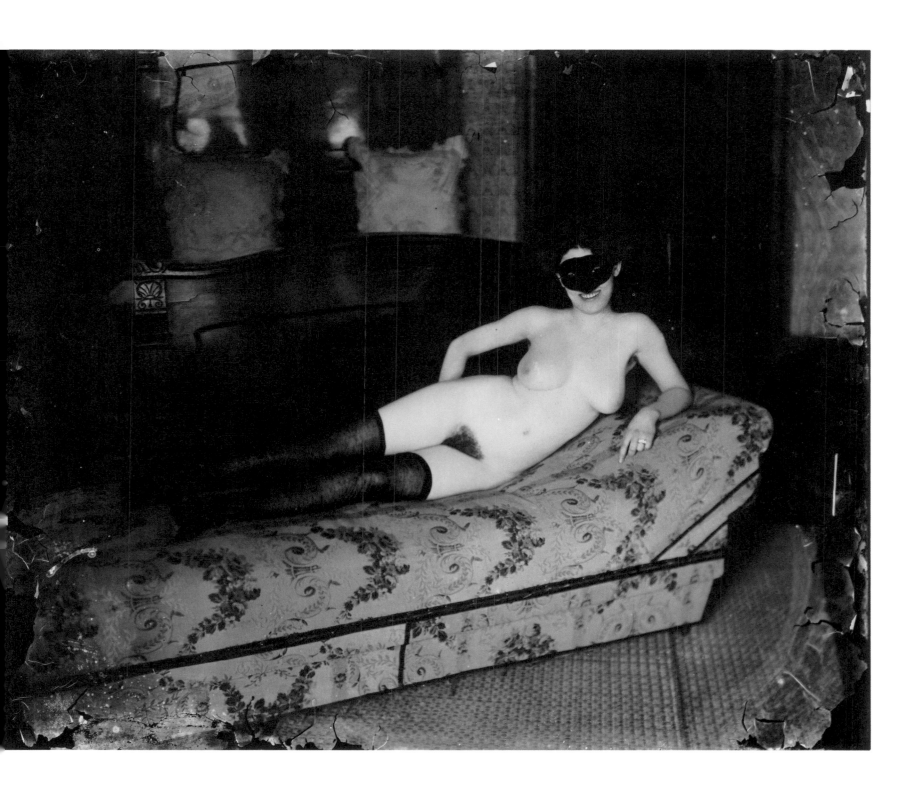

36 *Storyville Portrait* c1912
E J Bellocq American, active 1895–1930
Printed by Lee Friedlander in the 1970s on gold-toned printing out paper
20 × 25 119–1978
Purchase

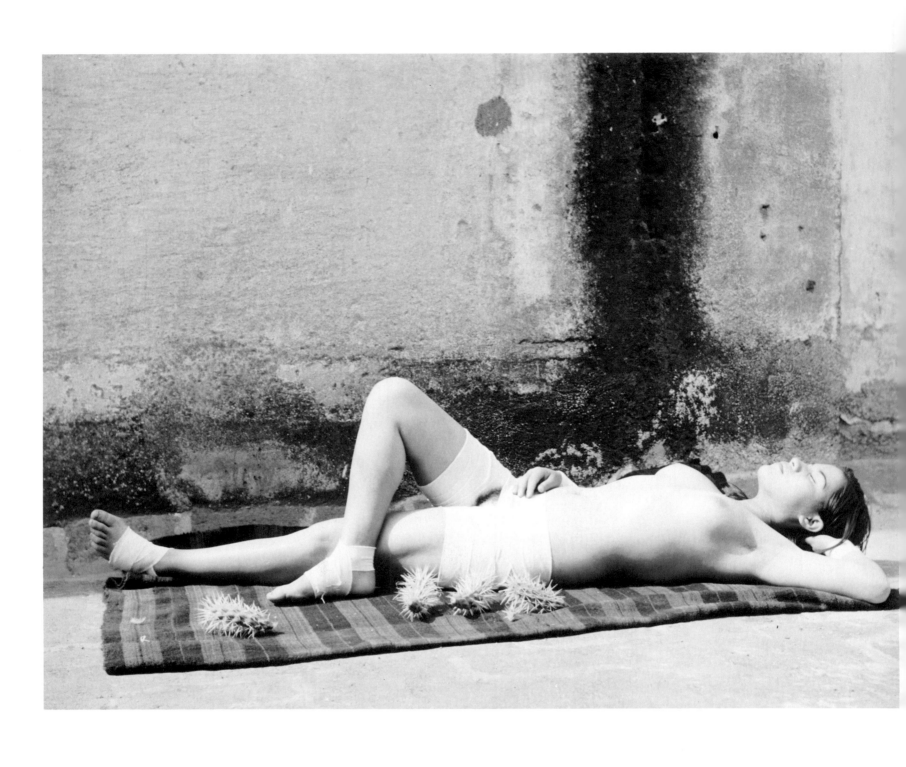

37 *La Buena Fama Durmiendo (Good Reputation Sleeping)* 1938
Manuel Alvarez Bravo Mexican, born 1904
Silver print (early 1970s) 18.7 × 24.4 224–1976
Purchase

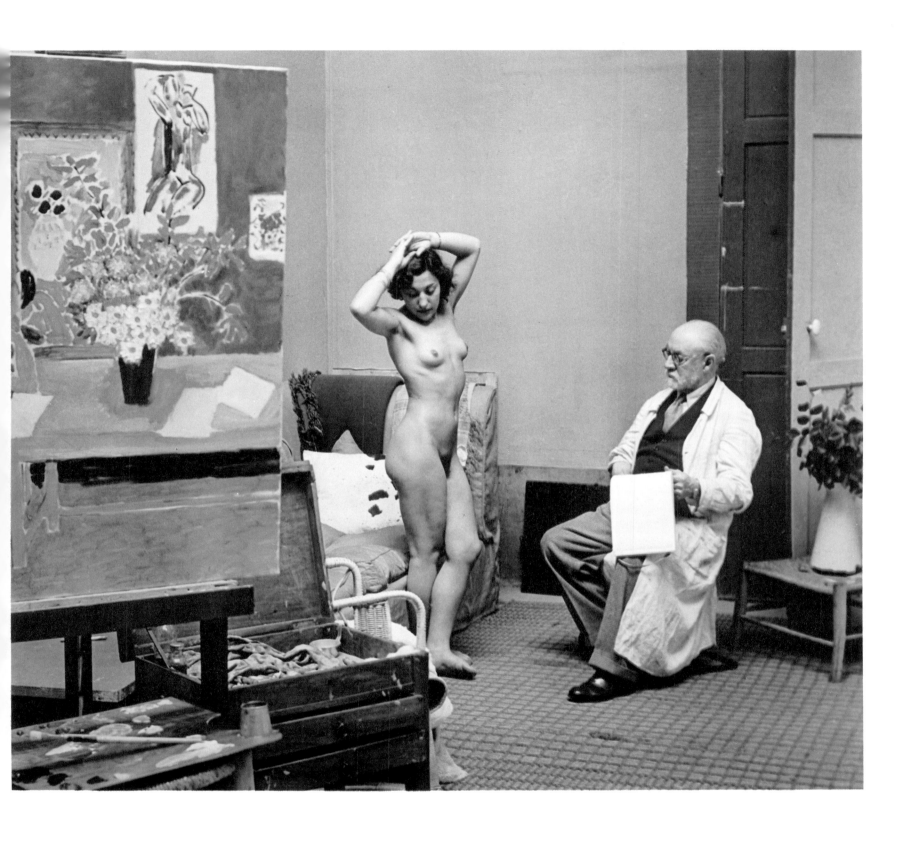

38 *Matisse with his Model* 1939
Brassaï (Gyula Halasz) French, born Transylvania 1899
Silver print (1973) 23.5 × 27.4 508–1975
Purchase

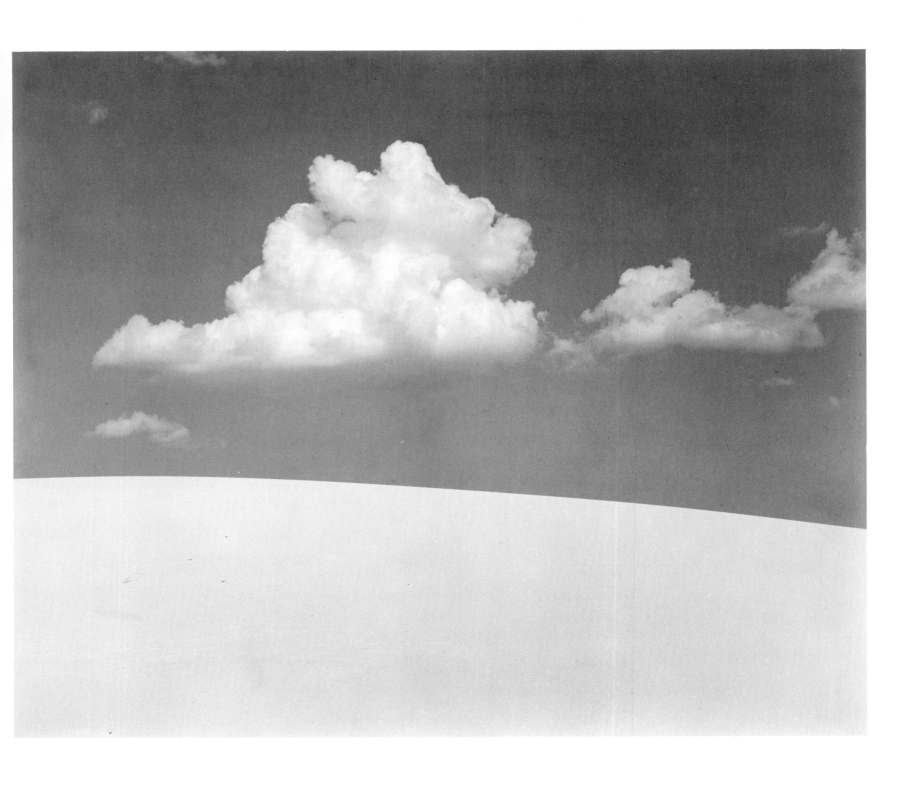

39 *Dunes* 1940
Edward Weston American, 1886–1958
Silver print 19.3 × 24.3 501–1979
Signed with initials on mount and dated
Purchase

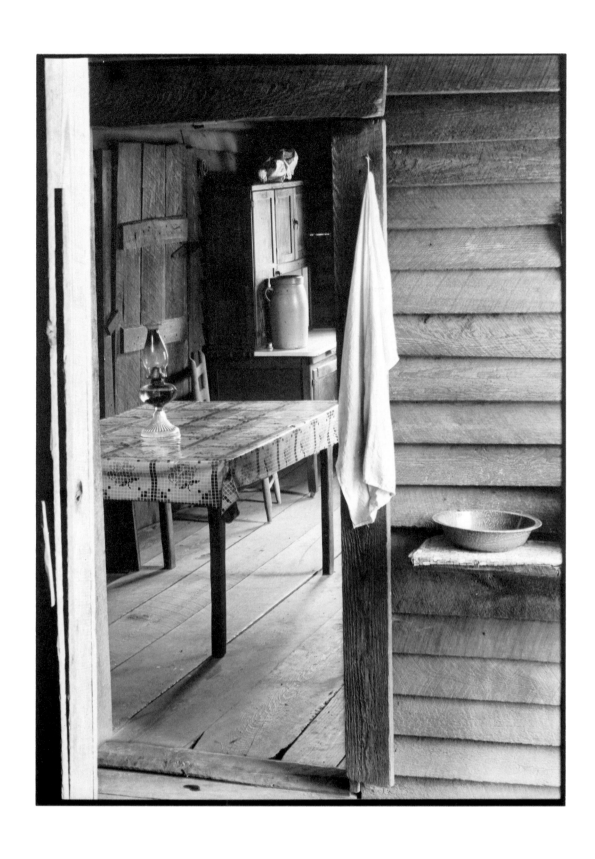

40 *Farmer's Kitchen, Hale County, Alabama* 1936
Walker Evans American, 1903–75
Silver print (1960s) 23.2 × 33.2 183–1977
Signed on reverse
Purchase

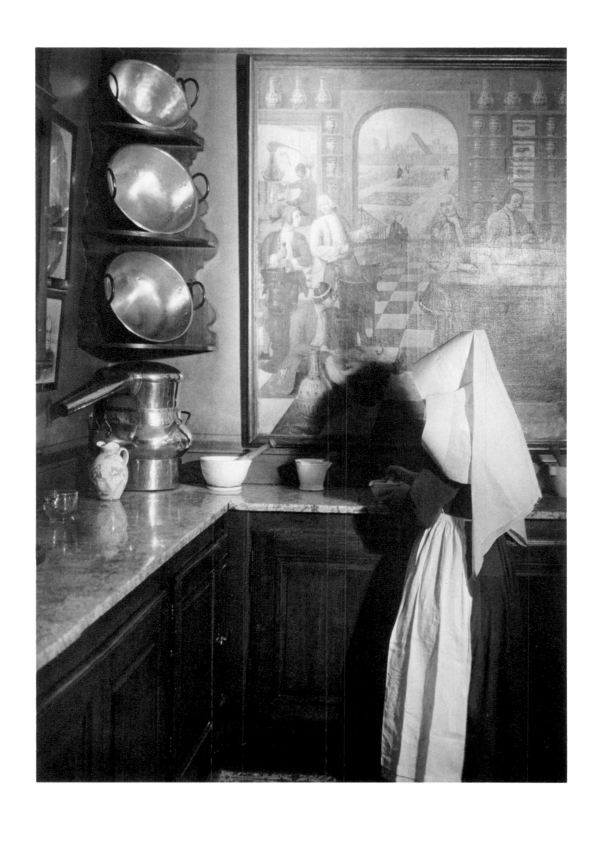

41 *Hospice de Beaune* 1951
Brassai (Gyula Halasz) French, born Transylvania 1899
Silver print (1973) 29.9 × 21.8 510–1975
Purchase

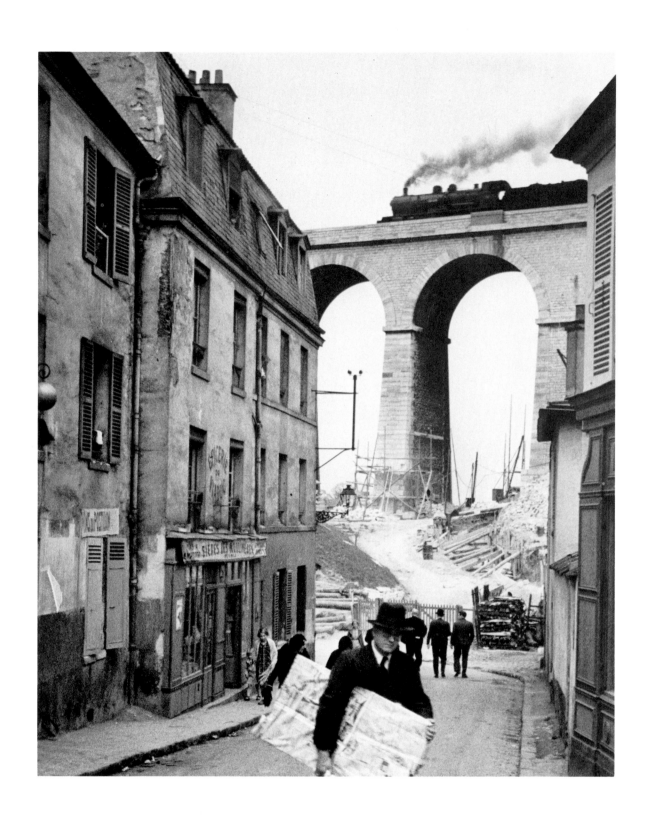

42 *Meudon* 1928
André Kertész American, born Hungary 1894
Silver print (early 1970s) 24.6 × 19.5 214–1976
Purchase

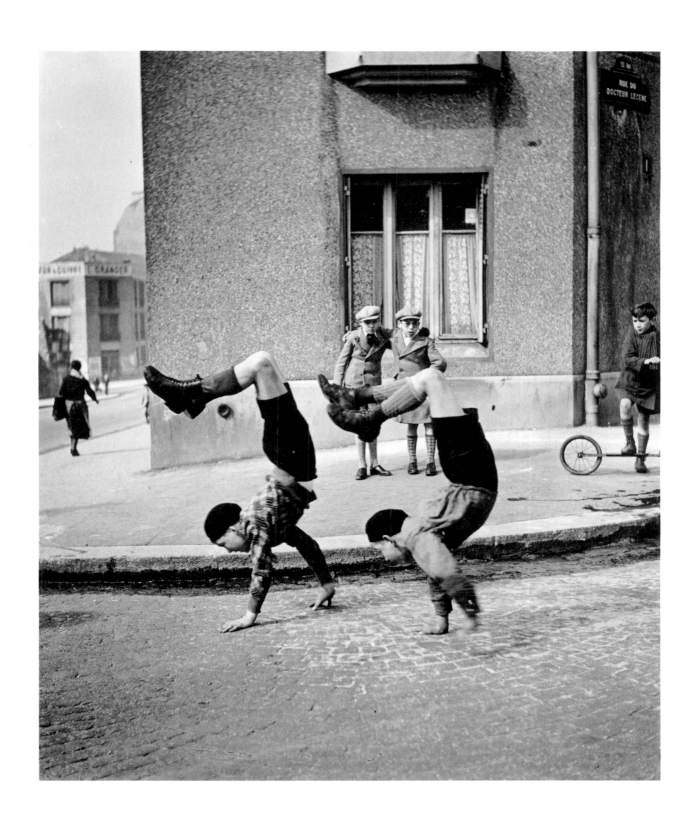

43 *Les Frères* 1937
Robert Doisneau French, born 1912
Silver print (1979) 28.3 × 24.3 268–1980
Purchase

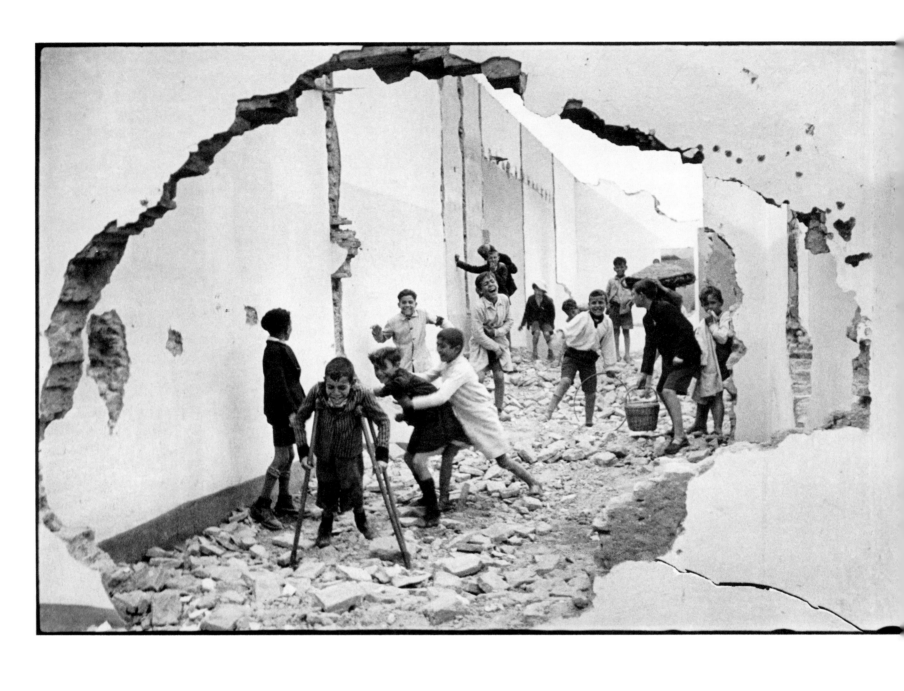

44 *Seville* 1933
Henri Cartier-Bresson French, born 1908
Silver print (1972–73) 24 × 36.1 582–1978
Purchase

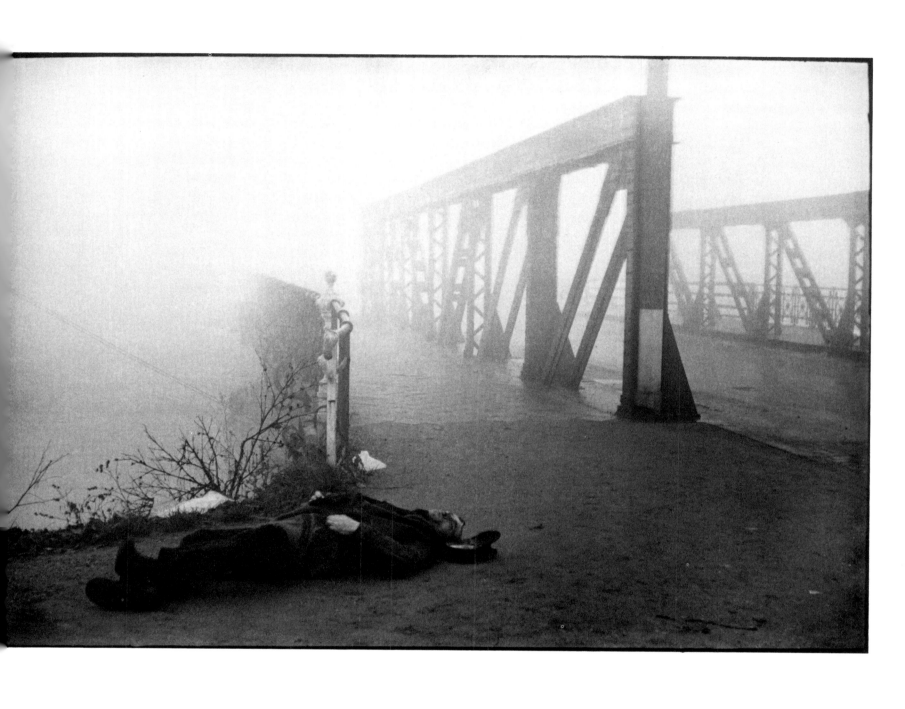

45 *French Resistance, banks of the Rhine* 1944
Henri Cartier-Bresson French, born 1908
Silver print (1972–73) 23.7 × 35.4 479–1978
Purchase

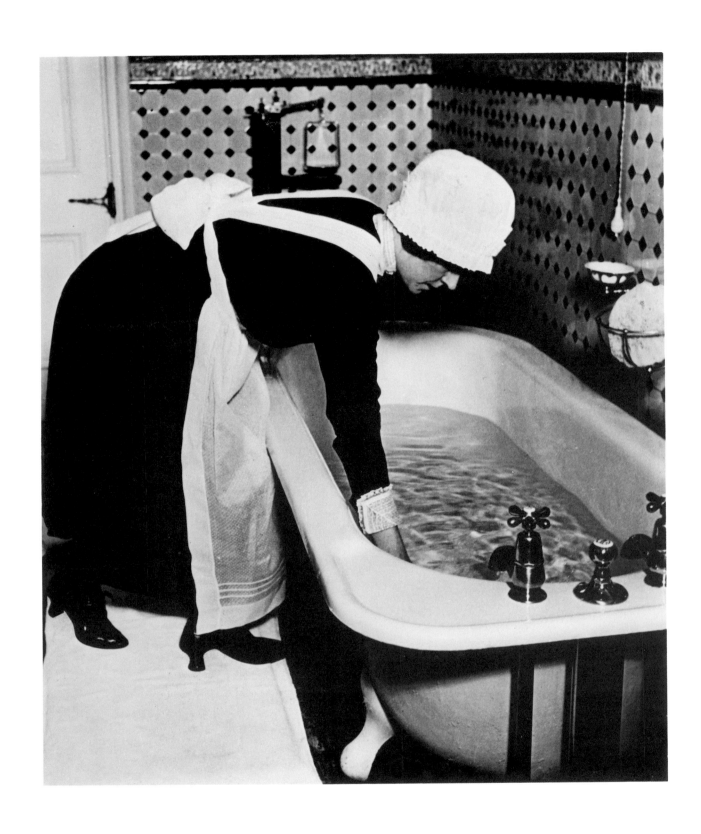

46 *Parlourmaid preparing a bath before dinner* 1937
Bill Brandt British, born 1904
Silver print (1977) 34.1 × 29.2 34–1978
Signed on the mount
Purchase

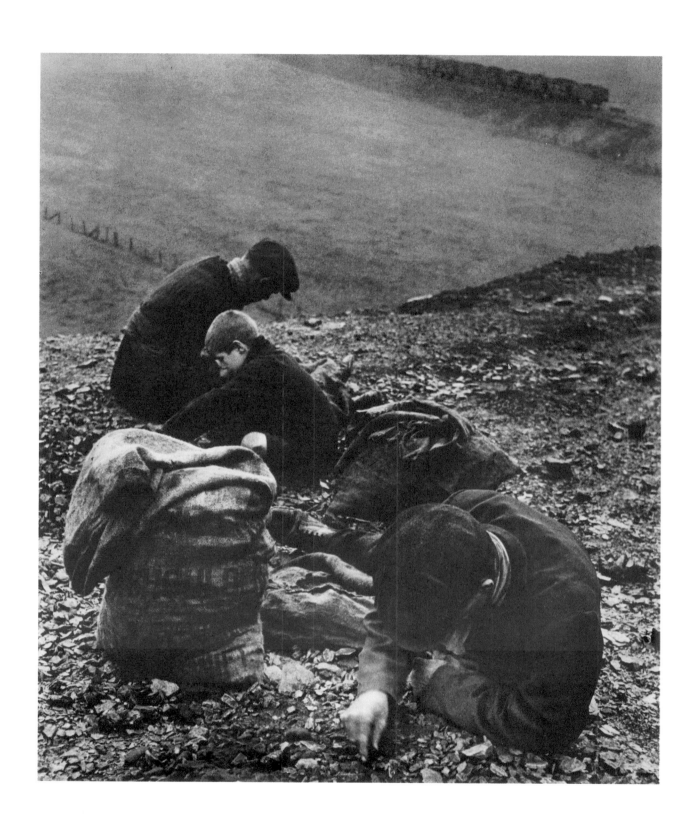

47 *Coal searchers near Heworth, Tyneside, pithead train in distance* 1937
Bill Brandt British, born 1904
Silver print (1977) 33.5 × 28.9 49–1978
Signed on the mount
Purchase

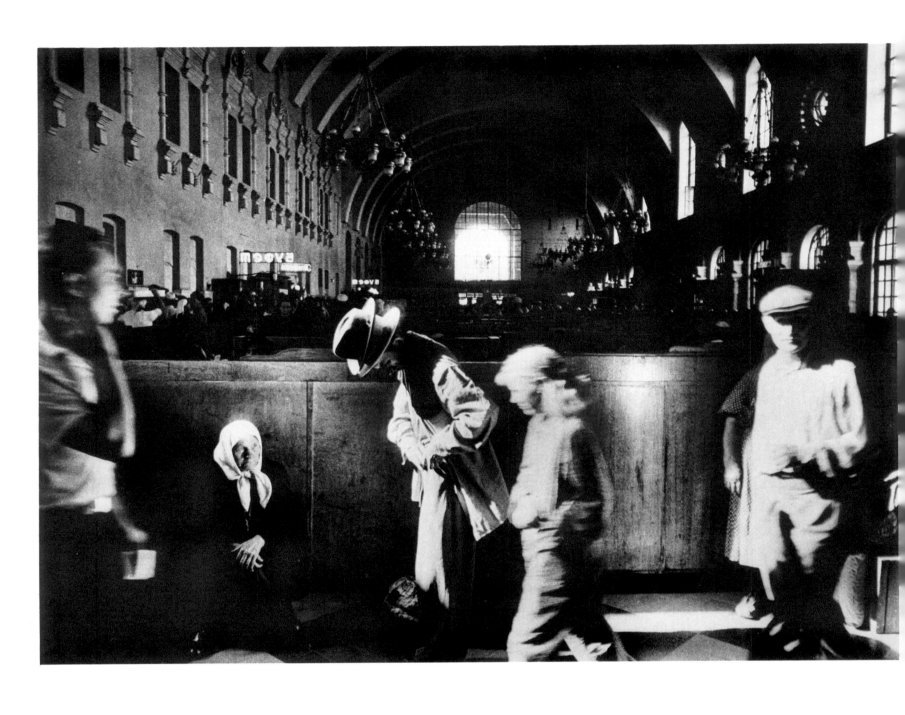

48 *Railway Station, Moscow* 1959
William Klein American, born 1926
Silver print (1979) 33.7 × 47.1 502–1979
Purchase

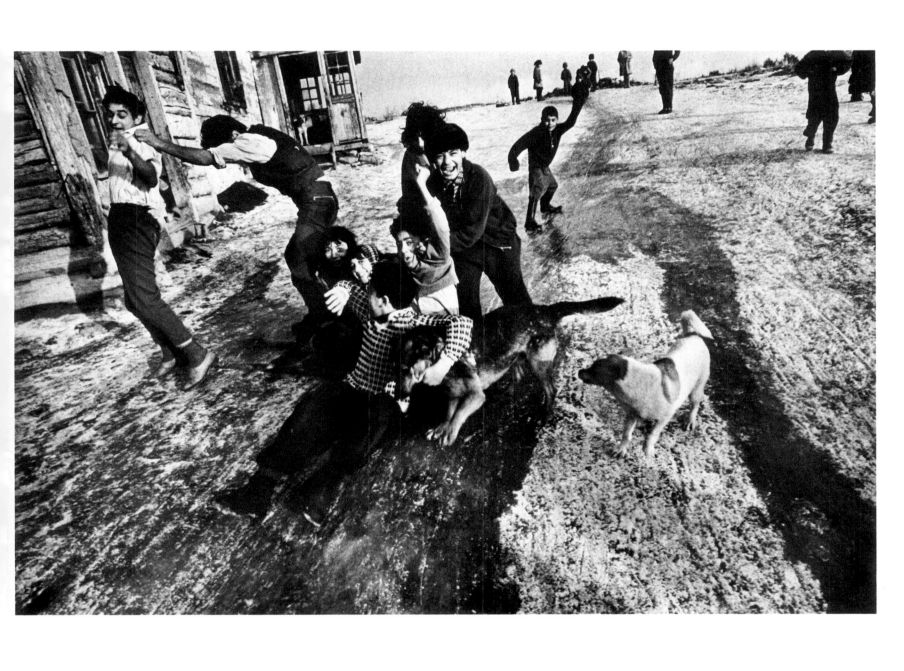

49 *Rakusy* 1964
Josef Koudelka born Czechoslovakia 1939
Silver print (1976) 23.7 × 36 Circ. 514–1976
Signed
Purchase

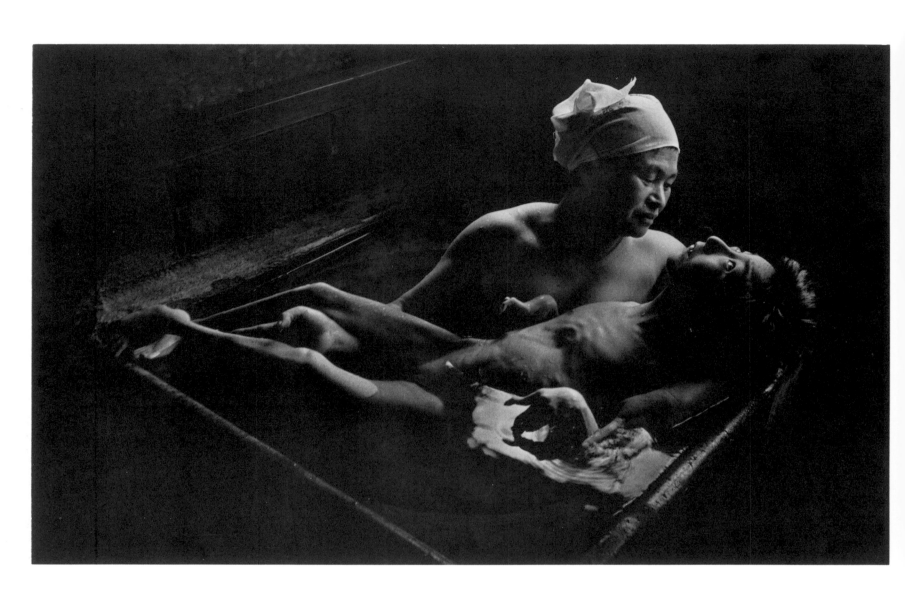

50 *Tomoko and Mother, Minamata, Japan* 1972
W Eugene Smith American, 1918–78
Silver print 19.8 × 32 1052–1978
Purchase

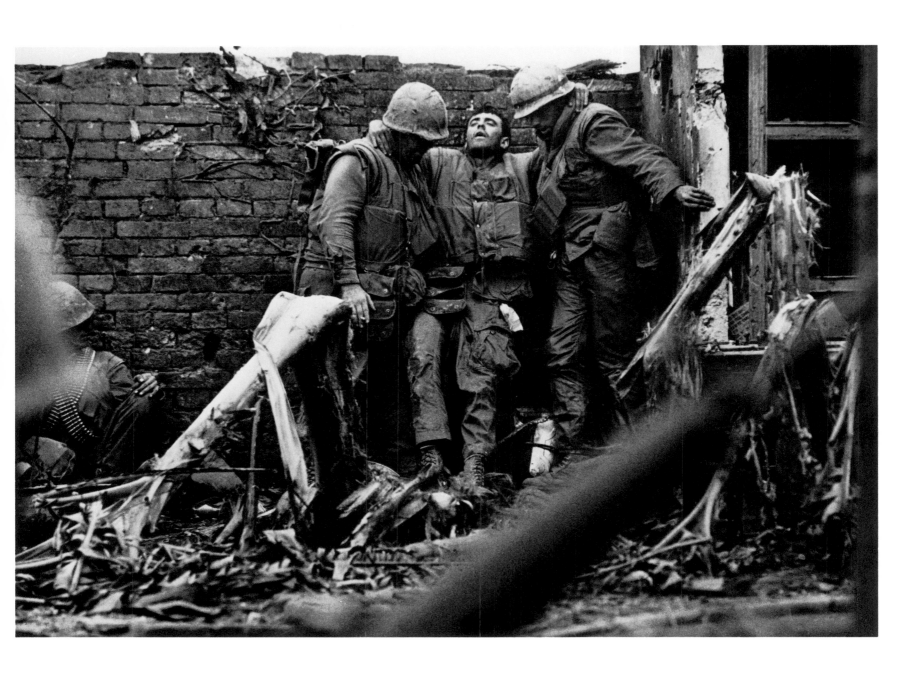

51 *Hué* 1968
Donald McCullin British, born 1935
Silver print 20 × 29.3 496–1979
Signed
Given by the photographer

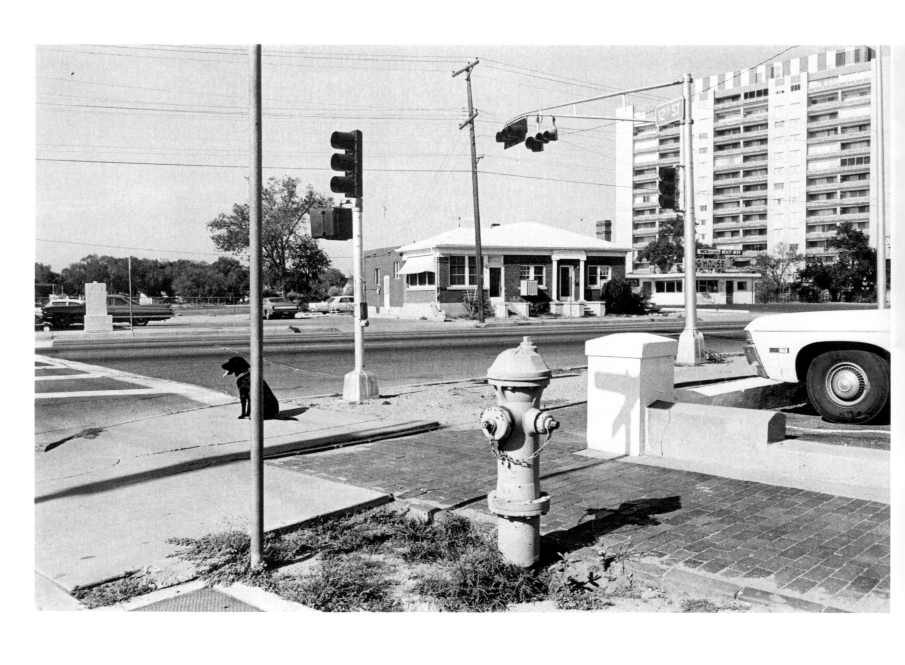

52 *Albuquerque, New Mexico* 1972
Lee Friedlander American, born 1934
Silver print 18.7 × 28.5 1029–1978
Signed in pencil on the mount
Purchase

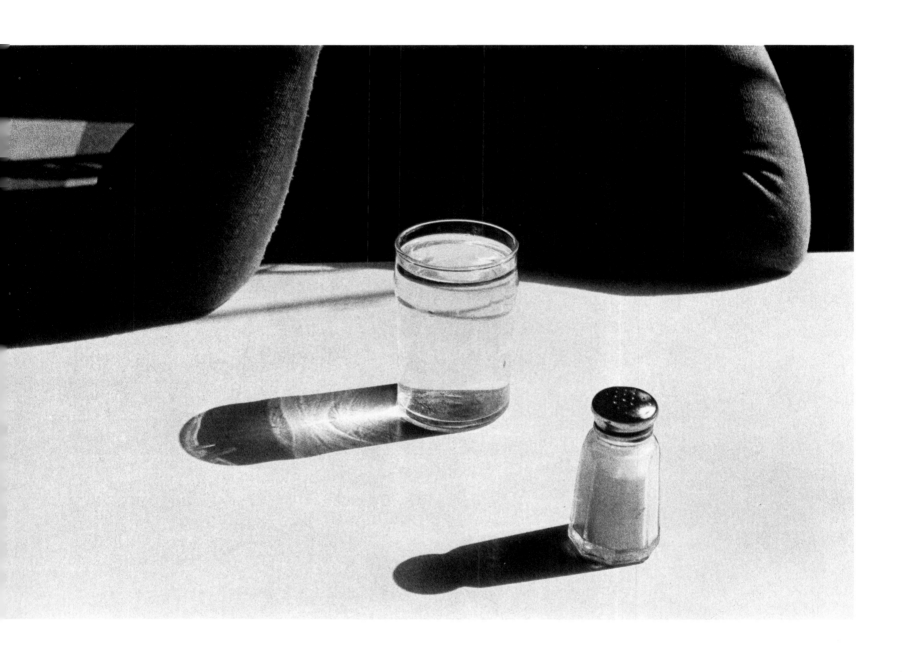

53 *Untitled* 1975
Ralph Gibson American, born 1939
Silver print 30.2 × 45.7 11–1979
Purchase

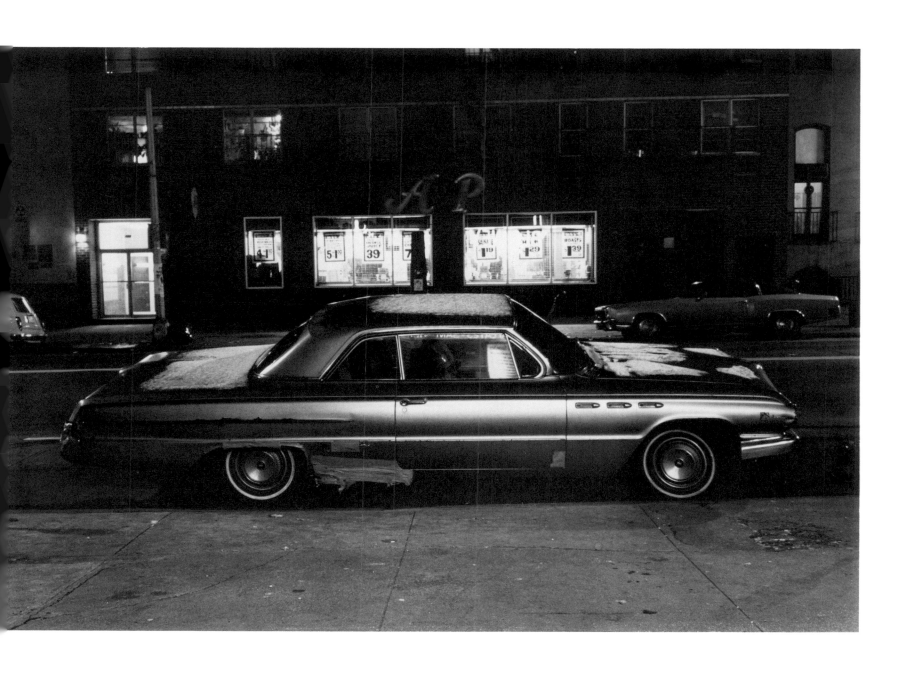

54 *A & P* 1975
Langdon Clay American, born 1949
C-type colour print 22.5 × 25.5 347–1978
Purchase

55 *Ape Ape Taro* 1976
Stan Tomita Japanese, born 1948
Silver print 33 × 25 499–1976
Purchase

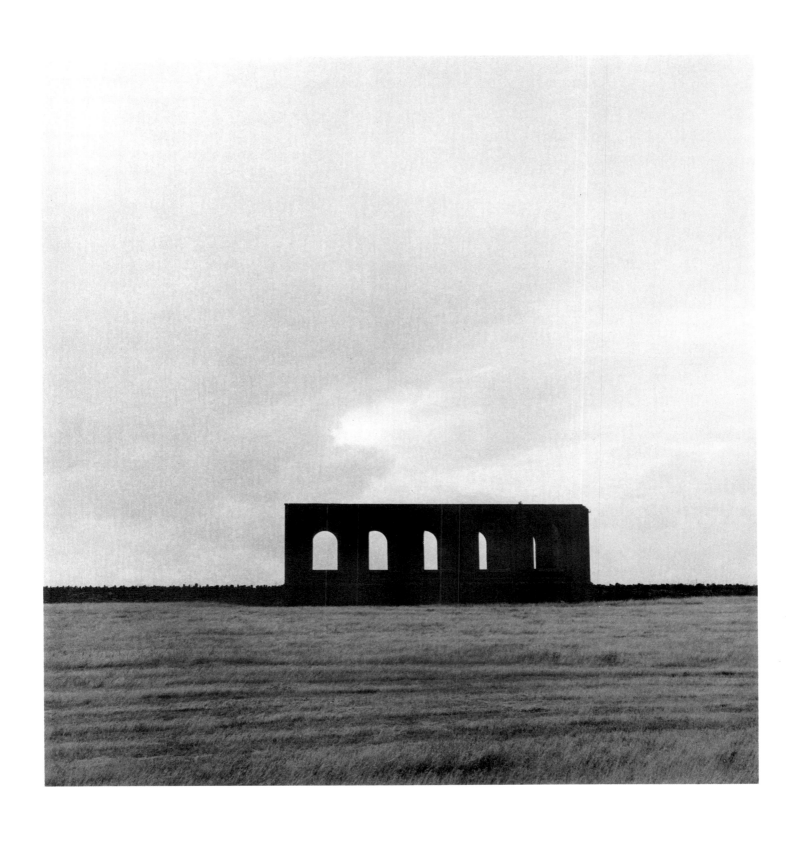

56 *Flimby* 1979
Raymond Moore British, born 1920
Silver print 24.7 × 24.4 495–1979
Purchase

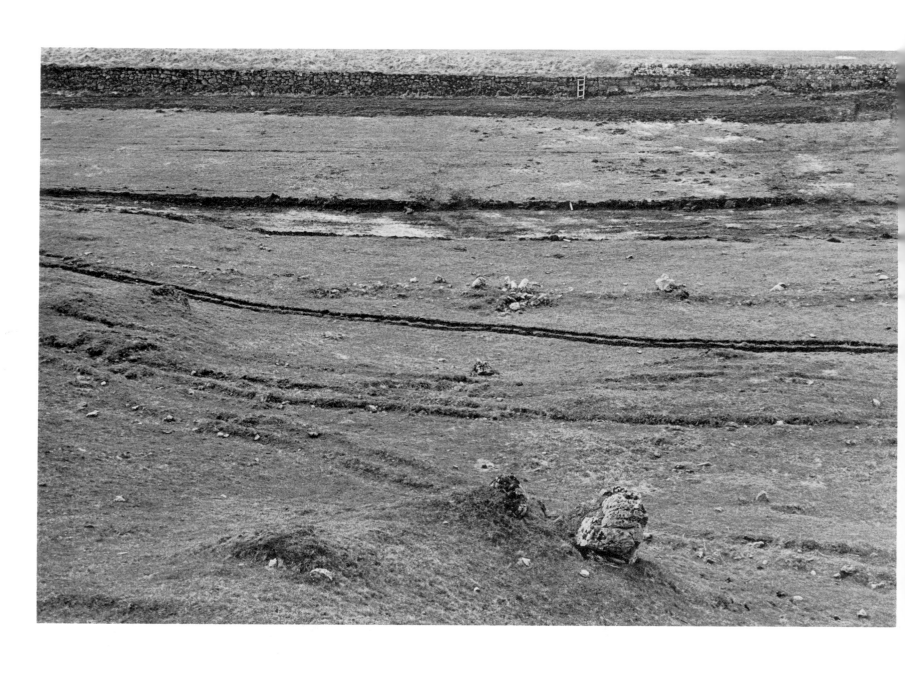

57 *Removed turf and disused railway line, Harborough Rocks,*
Derbyshire 1979
Paul Hill British, born 1940
Silver print 27 × 34 493–1979
Purchase

58 *Untitled* 1979
Amy Bedik American, born 1953
Silver print 25.5 × 25.5 490–1979
Purchase

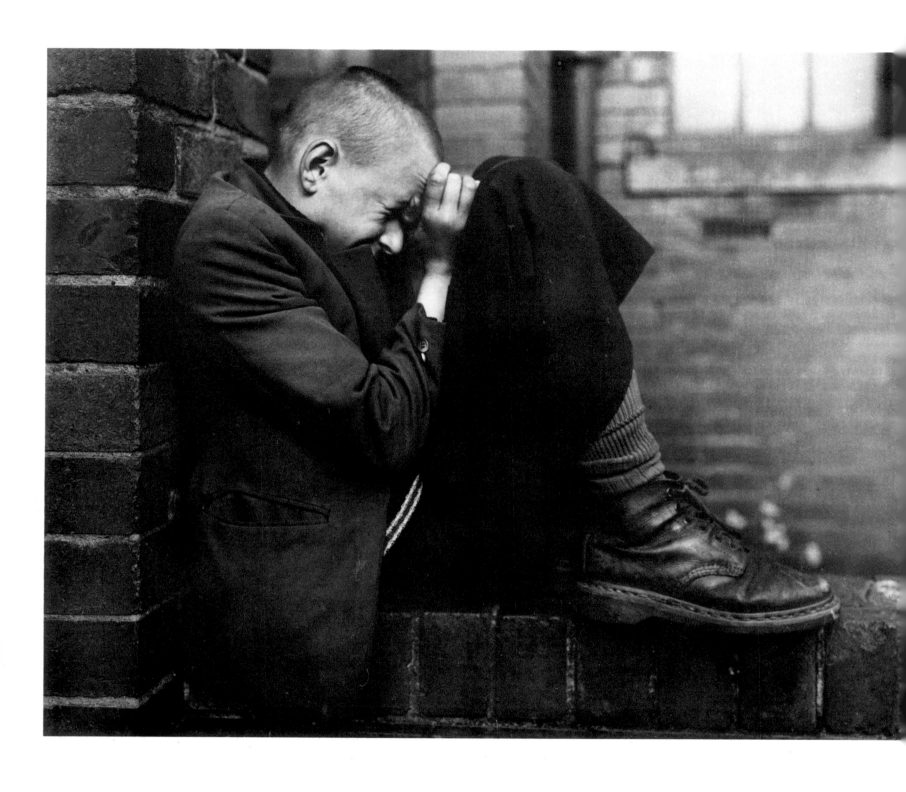

59 *Jarrow* 1976
Chris Killip British, born 1946
Silver print 20.2 × 25.5 852–1978
Purchase